Now We Are One
Faces of International Adoption

ISBN 1-933-197-38-2
EAN 978-1933197-38-8

First Published by Orange Frazer Press.

For more information on obtaining additional copies of *Now We Are One,* please visit *www.nowweareone.com*

Photography by Michael Wilson
Words by David Wecker
With Additional Text by Marguerite Gieseke
Essay by Melissa Fay Greene
Graphic Design by Jacob Drabik
Photograph of the Wilson Family by David Strasser

All proceeds from the sale of this book benefit not-for-profit international adoption organizations.

Library of Congress Cataloging-in-Publication Data

Now we are one : faces of international adoption / photographs by Michael Wilson ; words by David Wecker ; foreword by Marguerite Gieseke.
 p. cm.
 Includes bibliographical references and index.
 ISBN 978-1-933197-38-8 (alk. paper)
1. Intercountry adoption--Ohio--Cincinnati. 2. Adoption--Ohio--Cincinnati. I. Wilson, Michael Arthur, 1959- II. Wecker, David. III. Gieseke, Marguerite Schiff, 1967-
 HV875.5.N68 2007
 362.73409771'780222--dc22
 2007060105

Printed in Canada

Now We Are One
Faces of International Adoption

Photographs by Michael Wilson
Words by David Wecker
Foreword by Marguerite Gieseke
with an Essay by Melissa Fay Greene
author of *There is No Me Without You*

ORANGE FRAZER *PRESS*
Wilmington, Ohio

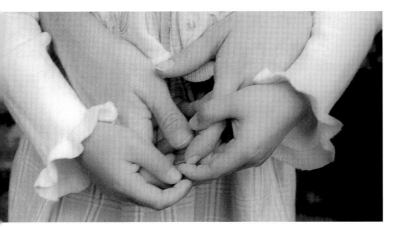

This book is dedicated to the

millions of children around the world

who are waiting for families of their own,

and all those who have a heart for them.

Contents

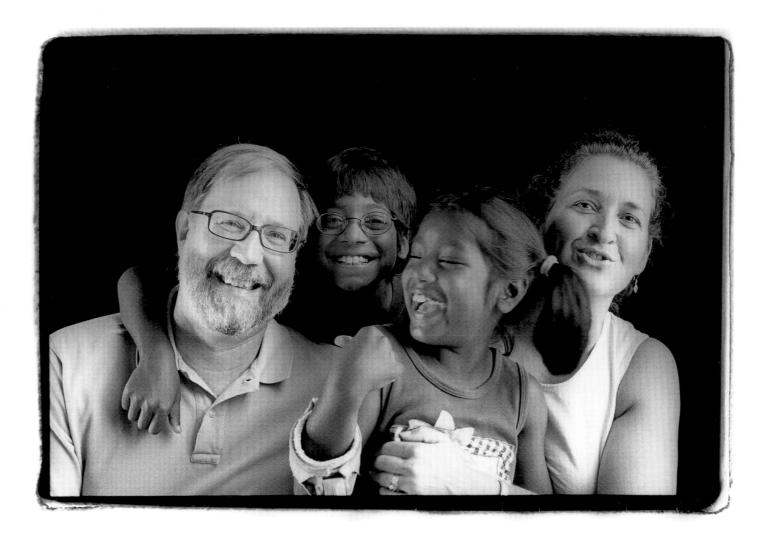

There is a place in the airport I will always consider sacred, an area just beyond the double yellow security tape at the foot of the escalators. This nondescript, completely undistinguished spot is connected in my mind to the power and true meaning of love. It was there that my husband and I introduced our son, Jamie, to his new family.

We had just stepped off the long flight from Guatemala where we had met Jamie and, after many complications and much legal red tape, had finalized his adoption. We were weary, excited and exhausted in equal measure by all that had transpired during our trip. As we were making our way down the long airport corridor, I saw ahead of us, a gathering of friends and family, waiting with eager faces, full hearts, and open arms. I knew then that Jamie, our son, was being welcomed into a family that already loved him mightily, that understood completely that he was now a crucial part of our lives forever.

Two years later, when we were blessed with Henry, another son born in Guatemala, I walked out of the plane and remembered that earlier arrival, the greeting in that special spot, and knew that Henry would be met with the same loving acceptance. Henry seemed to know it, too; when he looked into his sister's eyes for the very first time, he appeared to grasp that he was completely adored. His whole face shone bright and split into a huge dimpled grin. It was the beginning of a mutual admiration that will last a lifetime.

I was blessed with motherhood in two different ways. I gave birth to our daughters, and we adopted our sons. Both avenues to parenthood are magical. No thrill comes close to that of meeting your child for the first time, be it in a hospital delivery room or in an airport or orphanage. Your heart swells—in an actual physical sense—and something in you shifts. You fall in love. You know immediately that you would do anything for this child. In the trenches of parenting, biology doesn't matter. Genetics mean little. Love is what carries the day, what pulls you through, what holds the family together. There is no second best way to create a family.

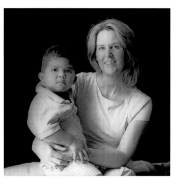

My hope for this book is that it will show families who have adopted internationally as beautifully ordinary. Many of the children who are photographed here have stories of unimaginable despair, stories that would break the hearts of even the most stoic, stories that graphically illustrate the terrible injustices heaped upon the young throughout the world. The forces of fate that bring adoptive parents and their children together might just as easily have passed them by. It is an unbearable truth that parents feel when we kiss our dear children good night and hold them tight against pain and sadness. These precious gifts were once so close to the suffering we watch nightly on the news—the earthquakes, mudslides, devastation of poverty and disease, tumult of international conflict. The thought of it can be overwhelming.

But this book is not about those sorrows, about the terrible losses at the beginning of so many stories of adoption. This book is about the simple, remarkably ordinary ways the survivors of those stories, those amazing children, have become vital members of their families, have used their unique gifts and talents and capacity for forgiveness and love to complete their families.

Adoption is a very personal leap of faith and a journey of love. These photographs chronicle that journey.

Marguerite Gieseke, August 05, 2006

Waiting for Mama

I hadn't been a citizen of the world of adoption for very long when I realized I was seeing the world differently.

Driving through our neighborhood one day, I saw two boys—school chums probably—strolling along together, wearing their backpacks, and kicking through the leaves. One white, one black, they seemed headed home from school.

"Oh," I thought, "*brothers.*"

My reactions to popular culture also changed.

The wildly popular movie *Shrek* alienated me, for the medieval fairy-tale populace was entirely white. In a computer-animated movie with a talking donkey, farm animals in tu-tus, green ogres and flying things, would it have been so hard to create diversity among the human beings? Could there not have been a few faces of color under the feathered caps?

As the white mother of four biological white children, one brown-skinned son from Bulgaria, and two Ethiopian children, would I have noticed that *Shrek's* land of fairy tales was an all-white enclave if we hadn't adopted?

I doubt it.

Would a white boy and a black boy have looked like brothers to me?

No.

Would I have realized that children growing up in a family together accept each other with matter-of-fact casualness as siblings, call each other "brother" and "sister" without research into genetic and national origins?

No, I couldn't have known.

Nor could I have known this: That every child is hard-wired to need a parent, like a flower needs, yearns, for the sun. That if a child's first parents are removed from the scene, the child will yearn and yearn until a new parent, or two new parents, appear. And that the child—if not too badly hurt from the years in between—will attach to the new parent or parents readily, like a morning glory vine clinging to the mailbox post and climbing up it.

I suppose I would have acknowledged that such human behavior was likely.

But I'd never have seen it.

In the chilly office of the orphanage director of a rural Bulgarian orphanage in 1999, a small black-eyed Romany (Gypsy) boy was led into the room to meet me. He was four. He obediently came to stand beside me. No one had told him that I was the potential new mama; in fact, I'd specifically asked the staff not to say, 'Mama' in front of the little boy, since this was just the first of two required trips in the Bulgarian adoption process. What if it didn't work out? What if I were not approved? What if we didn't get along? What if a return trip to complete the adoption was unlikely?

Within two hours, the little boy was calling me Mama. I didn't understand a word of Bulgarian, but I understood that much.

Over the next few days, I began to feel that the little boy was not only calling me Mama but that he had understood instantly and permanently that I was his mother.

I don't know if he thought that I was his first and missing mother (he'd been placed in government care at the age of seventeen months) or if he thought that all children endured a chilly, loveless, and institutional start in life while waiting for their mothers to arrive. But I sensed that a place had been carved out in his mind, in his soul—by the millennia of human development, by the evolution of life on earth—for Mama.

And, finally, she had shown up. And it was me.

On our first night together in a nearby apartment, I watched him rock himself almost violently back-and-forth sitting up on my bed. Then he fell backwards and rocked his head roughly back and forth on his pillow.

I thought, "He has no one. No one has rocked him."

I thought: "People aren't lining up to fly to Bulgaria to meet him. I may be his only chance for a mother."

The millennia of human development and life on earth had carved out a place in me, for motherhood, for parenthood. That night I discovered it could be activated not only by the darling children to whom I'd given birth, but by this strange little boy rocking himself to sleep.

Eight months later, all paperwork completed and approved, I returned to Bulgaria to bring the little boy home.

"Mama!" he cried in high-voiced ecstasy when he saw me, launching himself off a porch step into my arms.

And he's never looked back, not once in eight years, to ask, "Why you? Why me? Was this supposed to happen?"

The closest he's ever come to appraising the odd events was his remark one day, apropos of nothing: "I just didn't know that mamas had boingy hair." He has always been amused by my curly hair. But I understood his comment to mean, in a sense: 'I knew there were *mothers* in the world, of course. I just didn't know what mine was going to look like.'

A few years ago, I went with a few of my older children to see the science fiction movie, *A.I.,* which imagines a future of too few children, in which parents purchase child-robots as substitutes. An angelic-looking robot boy can be turned on by a woman reciting specific code-words. *Be careful,* advises the instruction manual that comes with this sophisticated home appliance. *Once activated, the robot child will forever recognize you as its mother.* Drawing a deep breath, the sad woman in the movie pronounces the code words aloud and the robot child awakens and falls in love with her, instantly and deeply and forever, like only a handsome little boy can adore his mother.

I sobbed through the entire movie.

"Were you crying because it wasn't a very good movie?" asked my then nineteen-year-old son Seth.

"No," I wept.

"Were you crying because it was a fairly derivative plot-line?"

"No!" I said.

"Were you crying because you wish we'd gone out to dinner instead?"

"No!" I said, laughing and crying at once. "I'm *crying* because it's the story of me and Jesse."

Every adoption is different.

And yet every adoption is the same. Adoption is the story, over and over and over, tinted in ten thousand different hues, sung in ten thousand different melodies, performed on ten thousand different landscapes, of the ancient human place in each child that cries out for Mama! Papa! And it's the ancient human place in each adult that cries out, Child! Adoption is the story of these primal human magnets smashing together with a powerful and joyful clang.

Melissa Fay Greene, January 16, 2007
www.thereisnomewithoutyou.com

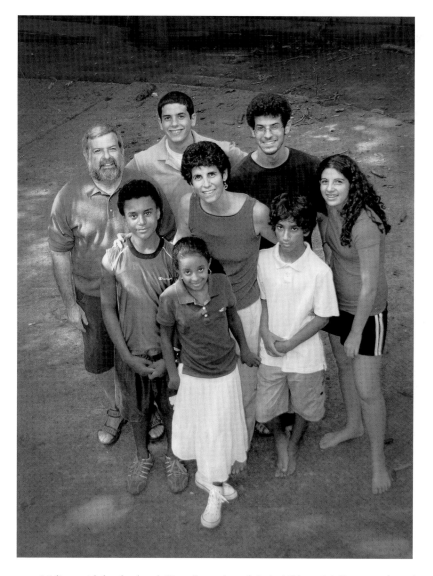

Melissa with her husband, Don Samuel, and their children (Molly is not shown)

Everyday Gifts

The Gieseke Family

Introducing the Giesekes:
Maggie, Karl, Anna Kirwan,
Mary Kirwan, Lillian, Jamie, Henry

Maggie and Karl Gieseke were completely taken with their three daughters. Anna, Mary and Lily were great girls, but still, something was missing. It occurred to them that they might need a boy, maybe even two boys, to complete their family.

The thought grew slowly, over time. They began the process to adopt in early 2002 and brought Jamie home from Guatemala the following year. Henry's adoption was completed two years later.

Jamie loves people; boy does he. Every new person, no matter who or where, is his potential best friend. As soon as he could speak the words, he would introduce himself to anyone and everyone he met. "Hello, I'm Jamie," he would say to the cashier at the grocery store, the bank teller, the lady at McDonald's, the guy at the gas station.

Now that he is a couple years older, his introductions have become more extensive. "Excuse me," he'll say politely. "I'm Jamie and this is my mom, Maggie. Right there is my little brother, Henry; that's my big sister, Lily, and I have two more sisters…" In this gentle way, he asserts himself. He makes it known that it's not just Jamie — it's Jamie and his mom and dad and sisters and brother.

Henry is round and happy. Around the neighborhood, he's known as his mother's sidekick. At the age of eight months, he planted himself on his mom's hip and stayed there for the next year and a half.

He learned quickly that he is really good at making people grin. He does this with a flash of his dimply smile or simply by arching his eyebrows, which seems to be turning into his signature expression.

Jamie loves to wrestle. He likes to pretend he's Buzz Lightyear. He has taken on the role of defending his family from the evil Emperor Zurg, an invisible bad guy who for some unknown reason has commandeered the Gieseke home as his base of operations for conquering the universe. "You need me to keep the family safe," Jamie tells his mom. Then he darts around a corner in pursuit of Zurg.

Henry is all wrapped up in his collection of Matchbox Cars. His pockets are usually spilling over with them. On occasions when he finds the need to pack more, he holds one car in each of his chubby fists and tucks a third under his chin. He seems so serious as he marches along, pockets and hands full, head down, shoulders scrunched up, until he raises his chin and out falls a tiny automobile. He usually falls asleep with one in each hand.

Henry hasn't given a lot of thought to what he wants to be when he grows up. Jamie's plans for the future vary depending on his mood. Sometimes, he wants to be an architect like his dad, drive a white car like his dad, go to an office like his dad and talk on the phone like his dad. Other times, he leans more toward becoming a superhero who would fly around saving people from tornadoes, fires and whatever else they need saving from.

"We needed our boys to complete our family as much as they needed a family to help them grow," Maggie says.

"They were both a perfect fit. It was our best decision ever to add to our family through adoption. We give our children as much love as we have, a family and a home. And they give that same thing back—plus something extra.

"It's that wonderful feeling that comes from having a full heart."

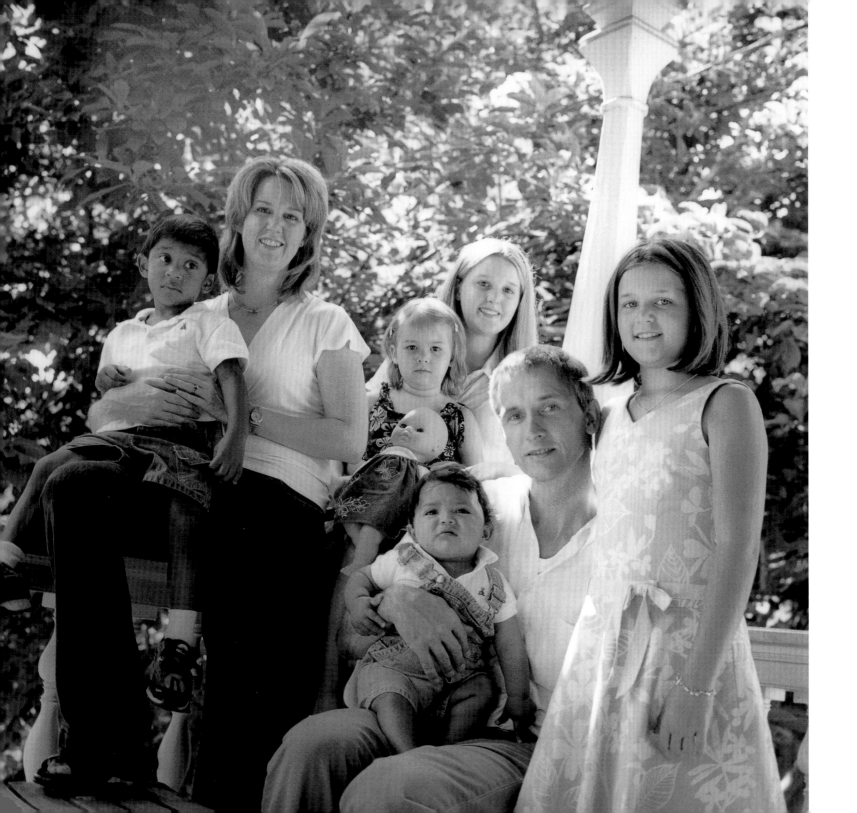

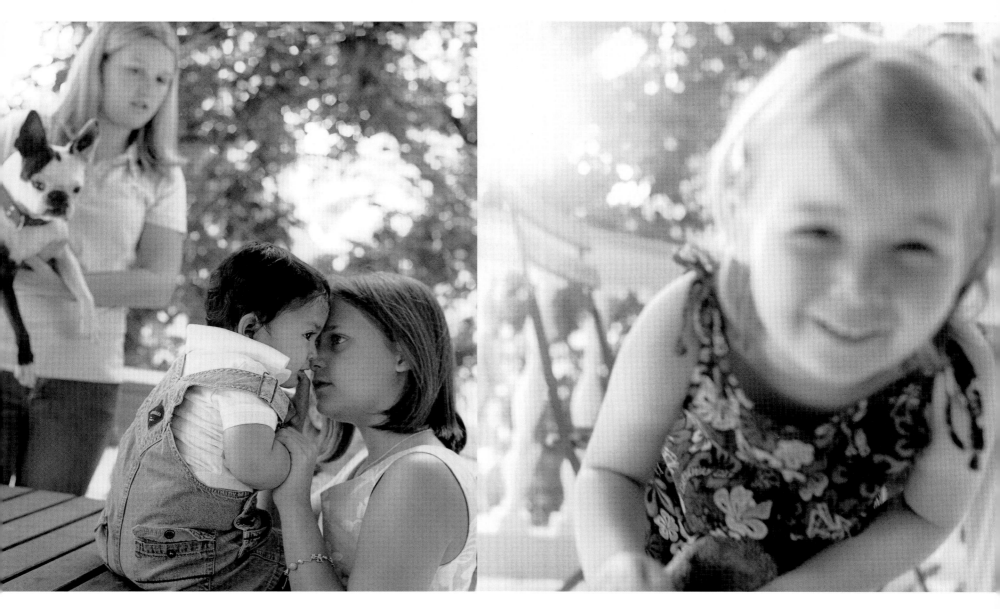

Photo by Jamie Gieseke

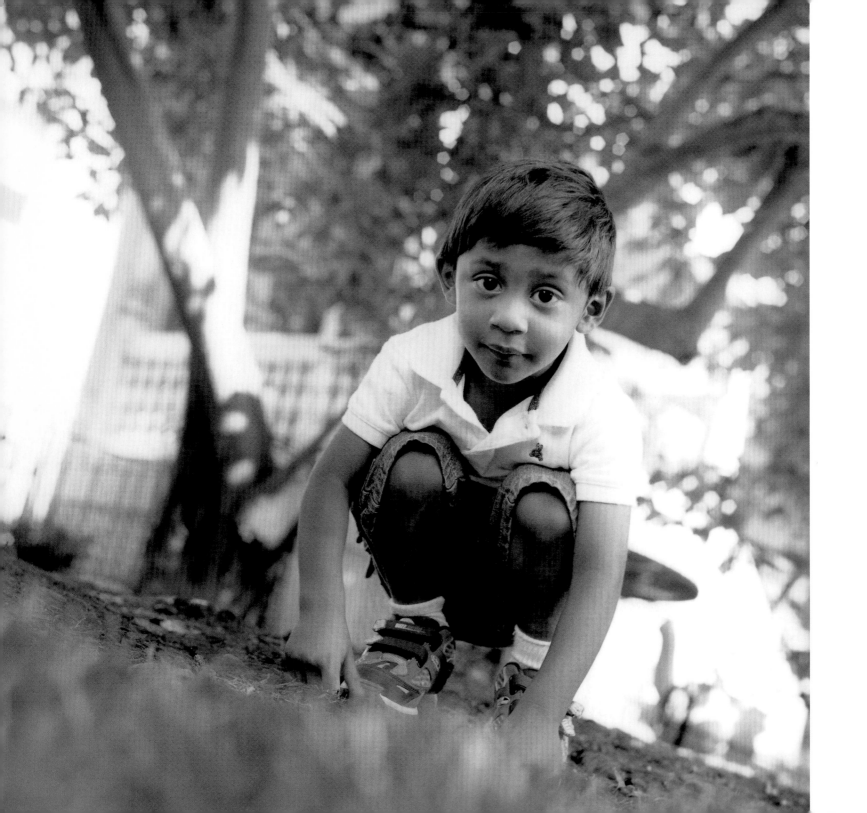

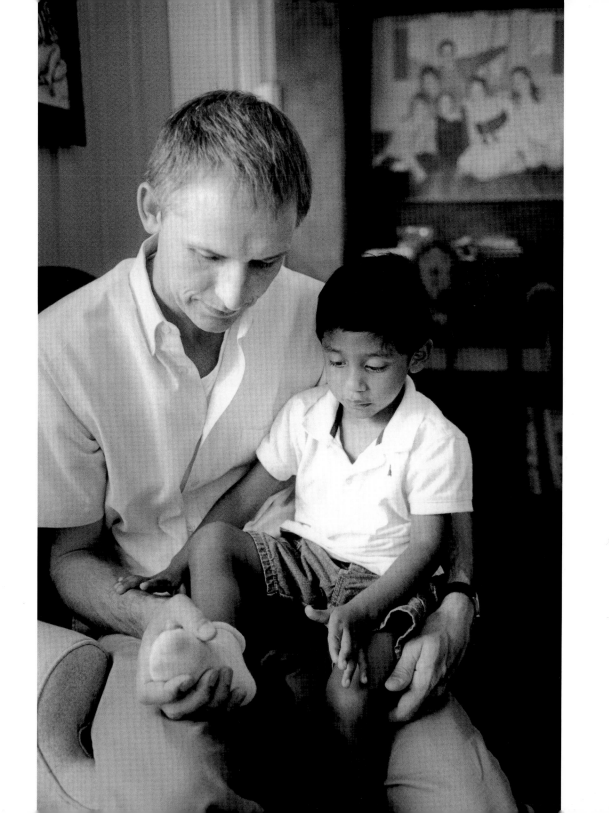

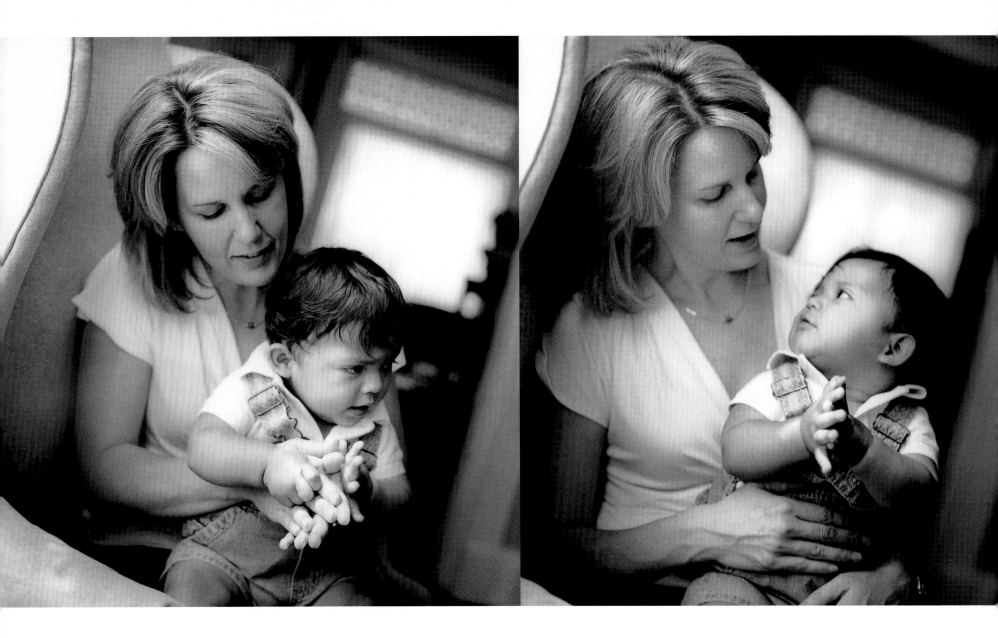

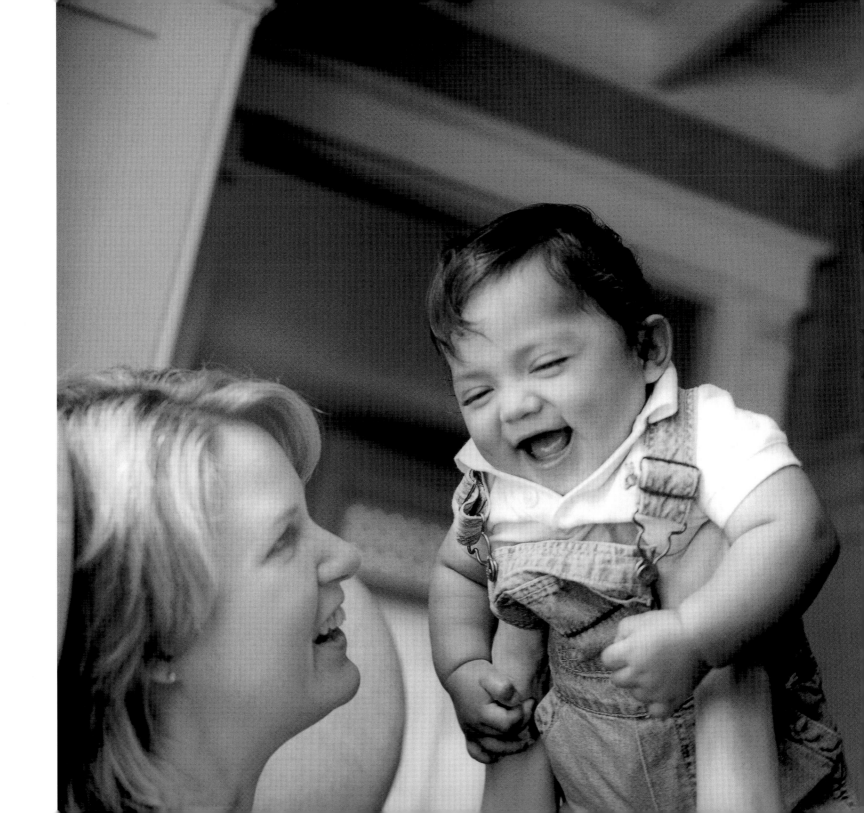

The Chung Family

Introducing the Chungs:
Kim Miller, Gene, Rachel, Benjamin

Kim Miller's childhood neighbor was a doctor who traveled to Vietnam with his Army Reserve unit each year to volunteer in a clinic. She was ten years old when he returned home with the first of his war orphans.

Each year for three years, he'd bring home another, each with cerebral palsy. None could walk. Kim remembers hearing he hadn't even discussed the third adoption with his wife.

But she was old enough to begin to understand the depth of what he and his wife had signed on to do — and to be impressed by it.

In 1974, at age eleven, Gene Chung immigrated to America with his Korean parents and two sisters. He met Kim in 1985, when they were students at the University of Massachusetts Medical School.

Early in their courtship, on maybe their second date, Kim learned Gene had been born in South Korea.

"I thought, 'Wow, that's great!'" she said. And she told him if they ever got married, they could adopt a child from Korea.

That raised an eyebrow with Gene. The expression about carts and horses and which goes first flitted through his mind. But he admired Kim's directness.

The moment could have been scripted. Kim and Gene married shortly after graduating from medical school in 1990. Their thinking

at the time was to have two biological children and adopt a third, from Korea. Rachel was born in 1993. When a second child was slow to come, the couple accelerated their plan to adopt the child they named Benjamin.

He's nine years old with shiny black hair, tall for his age, lean and really smart. He's boisterous, with a runaway imagination, sociable but quite able to amuse himself—and quite content to. At such times, he does amazingly intricate drawings of whatever is kicking around in his imagination.

Since Benjamin came along, Kim has limited her practice to twenty hours a week. Initially, she worked a full schedule. But almost from the minute Benjamin could talk, Gene says, "He was telling her, 'Me stay home, Momma stay home.'" So she did.

Rachel plays the drums and sings in her school choir. Benjamin's complex drawings show a flair for design. Both take Tae Kwan Do lessons.

Rachel welcomes the responsibility of being a big sister. She says it's cool to have someone who looks up to you, someone you can influence. "When we were waiting to get Benjamin, I couldn't wait to teach him what I know. Like *punch-buggy* and *no-punch-back*."

Maybe that is what whets Benjamin's appetite for wrestling. He sidles up to his dad. He challenges something his dad says. In a moment, they're tangled up, grinning happily, Benjamin squirming this way and that in his dad's arms.

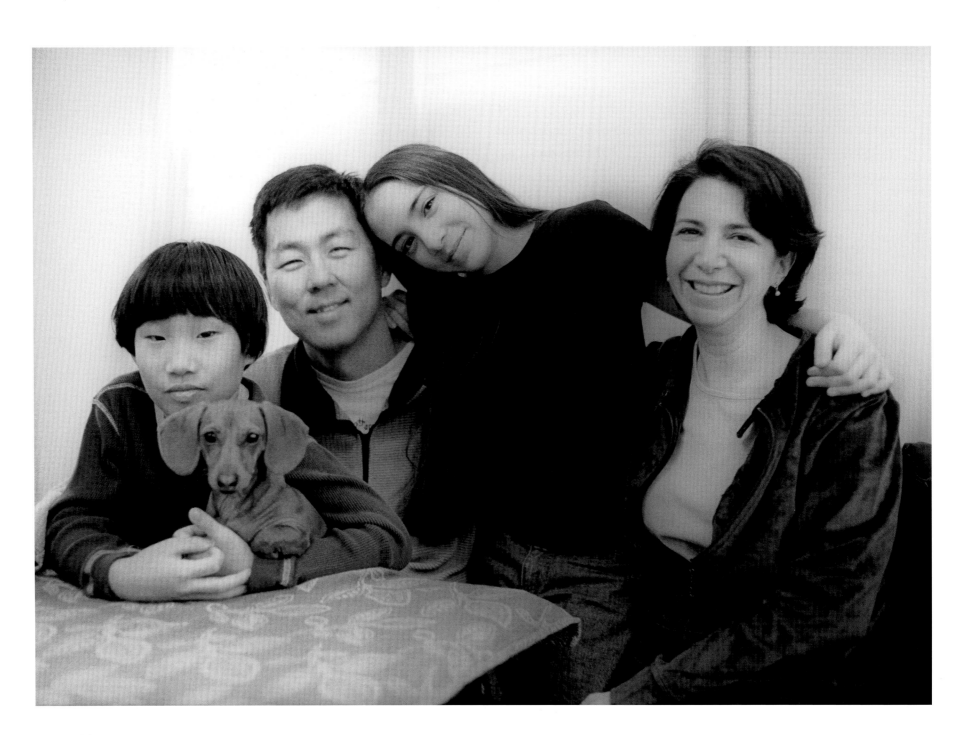

28

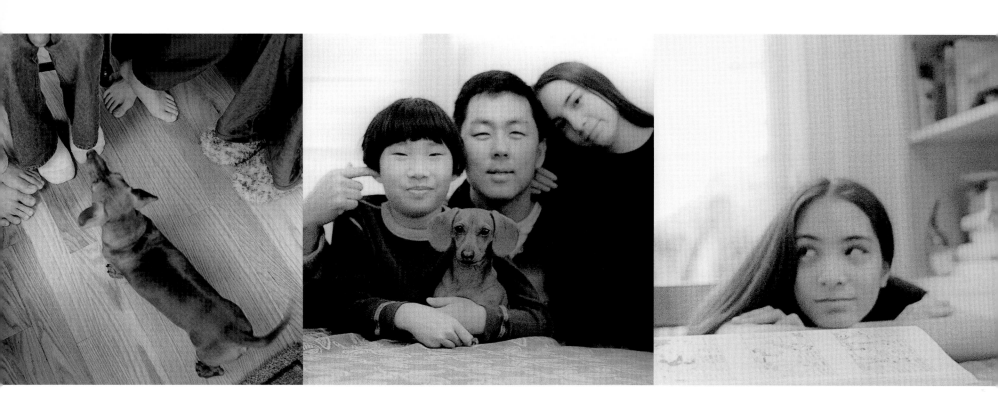

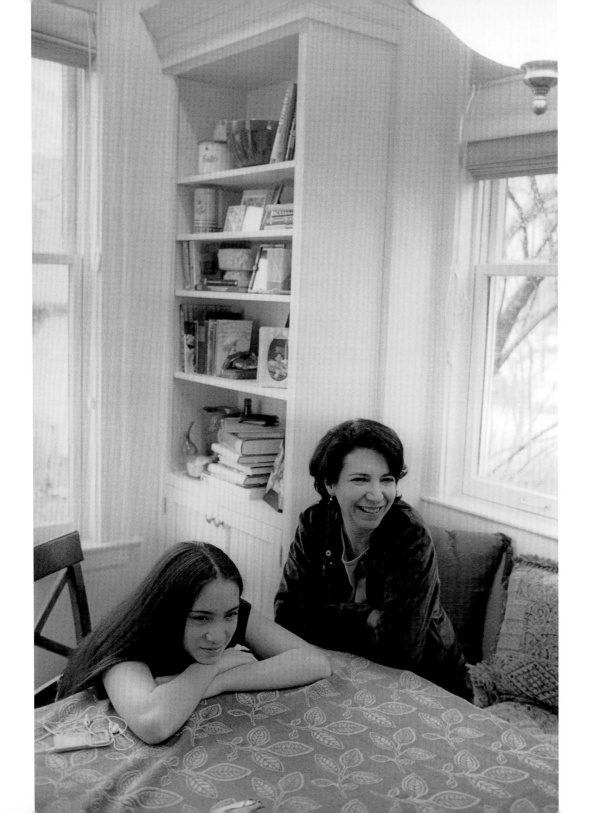

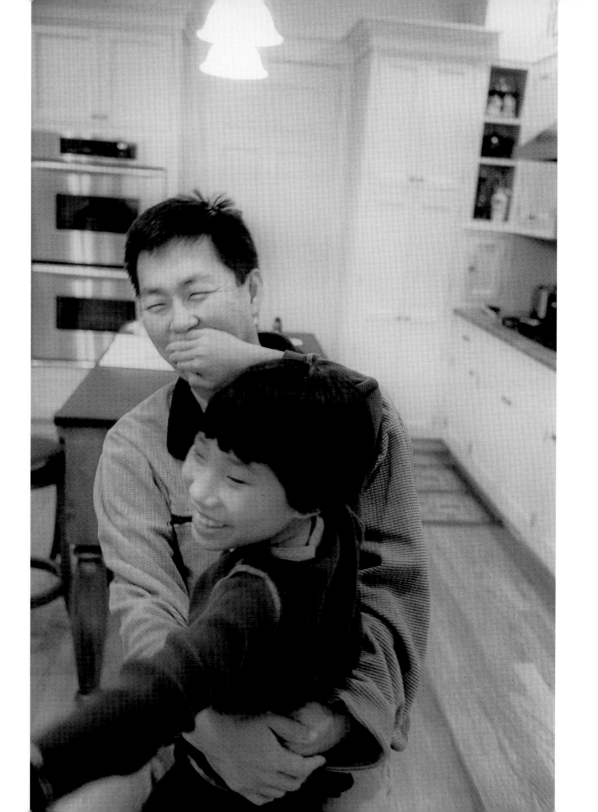

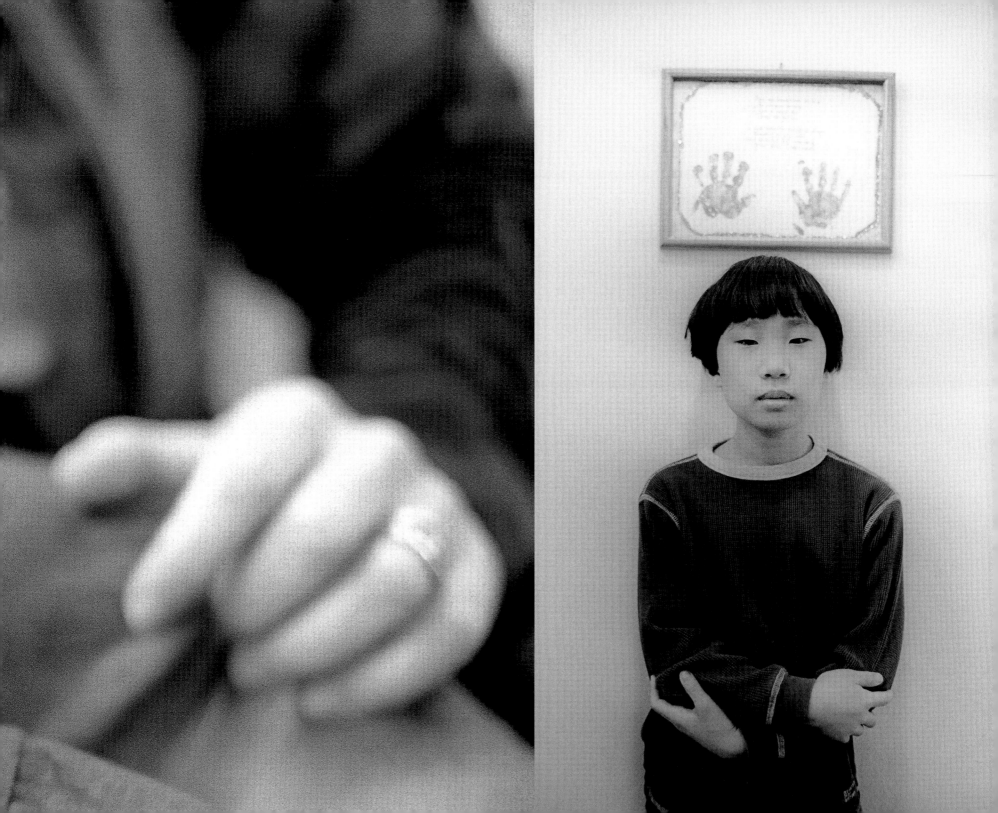

The Staat Family

Introducing the Staats:
Mary, George, Emily, Katie

For anyone thinking about adopting a child from a faraway place, Mary Staat has three wishes.

First, she wishes you will see the child as a gift from God and find joy in all you would learn about yourself through the ups and downs of parenting such a child.

Second, she wishes you would focus on what you can add to your child's life instead of thinking about how your child will fill in the blanks in your life.

Third, she wishes you would remember to enjoy the experience without worrying too much about what might not always go right.

Mary is a pediatrician. She also is founder and director of the International Adoption Center at Cincinnati Children's Hospital Medical Center. The IAC exists to help U.S. families adopting children from other countries address medical issues, developmental concerns, emotional needs and whatever else might present itself in the adoption process.

Mary hopes you would have the great good fortune she has had.

Mary's eldest, George, is sensitive, insightful, easy-going and unusually thoughtful for a fifteen-year-old. She recalls coming home one day in a stressed-out state, tearing into anyone in reach about clothes on the floor, toys not put away, garbage not being taken out, all the normal stuff.

George was five or six, and Mary was upset about something or another. After a few minutes of listening to her vent, he calmly interrupted. He said he didn't think he'd done anything wrong. So what, he wanted to know, was the real problem?

"I stopped in my tracks and realized I was taking my work troubles out on the kids," Mary said. She took a deep breath and told George about the frustrations of her day. He listened, nodded. Then together, they straightened up the house. She remembers it as the beginning of what continues to be a policy of open communication between them.

Then there's Emily, twelve, energetic, competitive and fun. Giving up is not in her nature. One story that stands out in Mary's mind was when Emily was in first grade and wanted to be a Brownie.

Emily is a joiner. With each paper that came home from school that year announcing something else to join, she would beg to sign up. By the time the forms for joining the Brownies arrived, Mary reached her limit. But Emily was determined. Some days later when Mary went to pick her up at after-care, Emily wasn't there. Her caregiver told Mary that Emily was down the hall at the Brownie meeting.

Mary marched down the hall, introduced herself to the Brownie leader and informed her that Emily did not have her permission to join the Brownies. "Oh?" the leader said. But leader had all the forms,

with all T's and I's crossed and dotted. Except that Emily had filled out all the paperwork herself—and in a tidier hand than her mother's. Mary wasn't happy at what her daughter had done, but she was mightily impressed that she'd figured out how to get it done.

Mary's third, eleven-year-old Katie, is creative, generous and compassionate. Of the three, Katie is the artist. She's especially good at "found art"—getting an idea and finding something around the house to make it happen.

Like the time she thought to create a pair of matching Bible cases for her and her mother. She put a great deal of thought into locating just the right size boxes, as evidenced by all the empty cereal and cracker boxes Mary found in the kitchen. Then Katie decorated the boxes with felt and made handles of ribbon. She included compartments for pens, highlighters, notepaper and other items one might want when reading the Bible.

These children have changed their mother. Mary admits she was once a driven, competitive person, one who didn't set aside much time for just plain living.

"They have made me a better person," Mary says.

"They brought me back to God. They gave real meaning to my life and helped me find purpose."

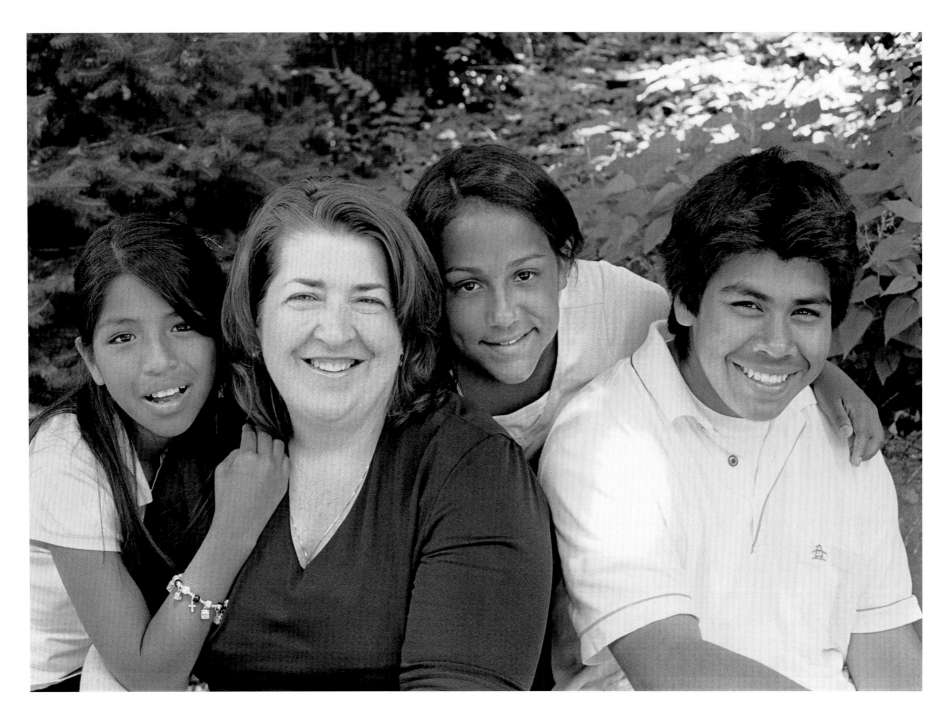

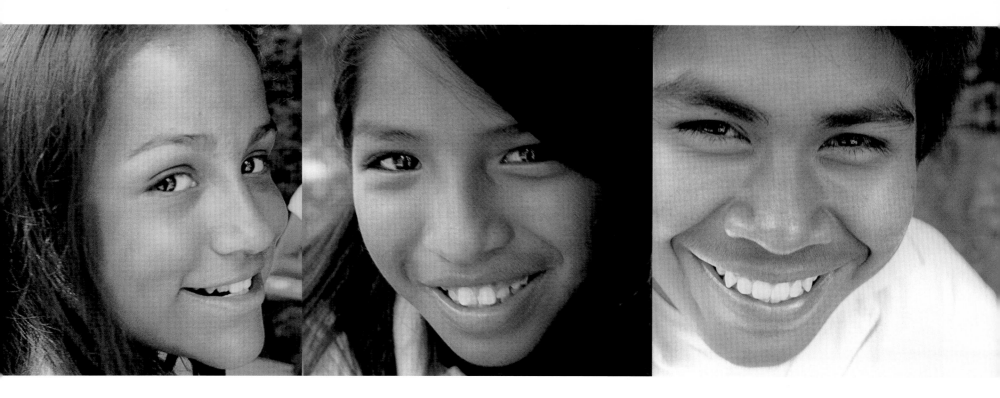

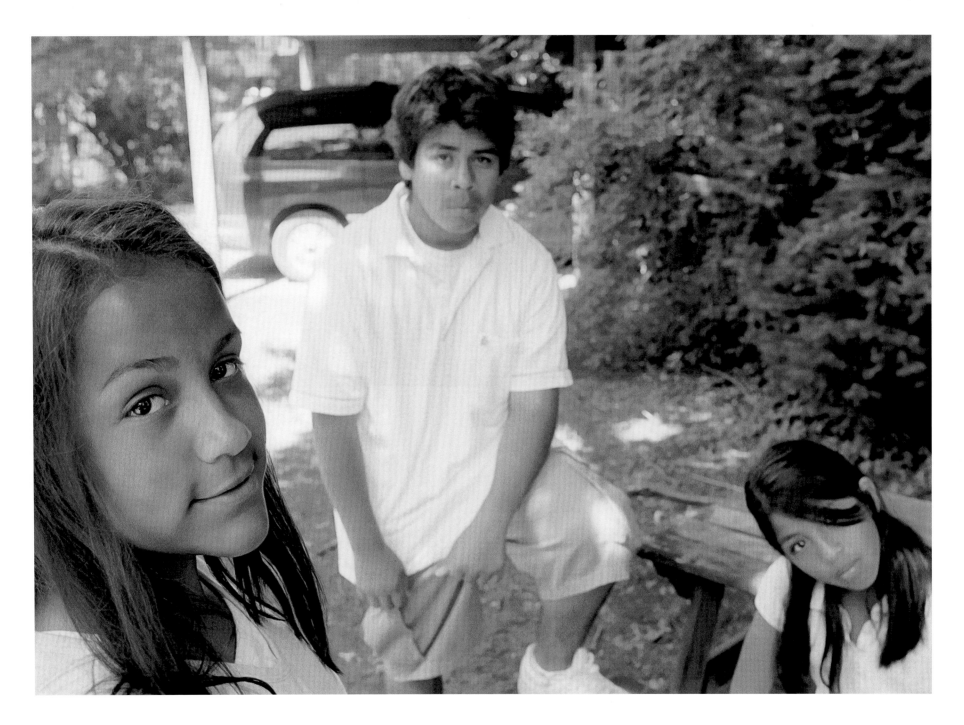

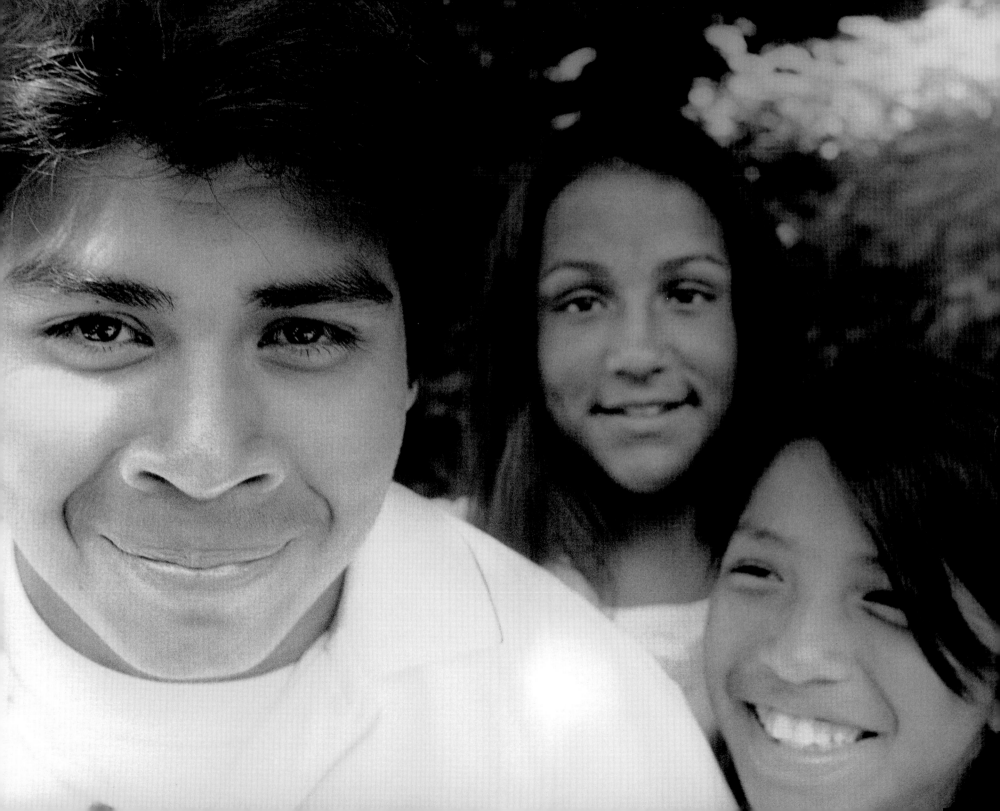

The Northrop Family

Introducing the Northrops:
Babette, Mark, Nico, Maria, Teo

Babette and Mark are the proud parents of four children: Nicolas, not quite six; Maria, who is four; and their two-year-old little brother, Theodore. Maya, who is three months old, is waiting in Guatemala. The Northrop's hope to be allowed to bring her home any day now.

The first time they saw Nicolas in Guatemala, he was seven months old. His foster mother had dressed him in a three-piece suit. Who knew they made such tiny suits? When they brought him home, Babette and Mark must have spent hundreds of hours just staring at him, marveling at how perfect he was. He is adept at any sport involving a ball. He also likes throwing rocks into any body of water. It's a safe bet he'll make a great rock skipper.

With Maria, it's all about music. When she arrives at her music class, she always hollers, "Hooray!" You might be in the middle of a conversation with her or having a sandwich and one of her favorite songs will come on the radio, at which point, she'll jump up and say, "Excuse me, I have to dance!" And off she goes. She can hardly contain herself when she hears certain kinds of music. Dancing spills out of her.

Theodore is the wordy one. At 26 months, he strings together entire sentences, pulling from a vocabulary of some 500 words. He provides a running commentary all day every day about what everyone in the family is up to and what he thinks about it. Maybe he will one day be a social commentator.

There are so many stories, so many moments, so many possibilities. Being a parent is unlike anything Babette and Mark imagined it would be—and they spent a lot of time imagining. They'd always thought of themselves as parents, dreaming about the life they would have with their children. They watched their friends and family members grow families of their own, wondering when they would get their turn. Then they decided to build their family through adoption.

Since Nico and then Maria and Theodore, Mark and Babette have learned that the joy comes mostly in small quiet moments.

Like when the kids get in bed with them to cuddle before they get up in the morning. Or when one comes to Babette with a hurt knee and needs a kiss. Or when another scores a goal in soccer and turns to look at his mom and dad in the bleachers to make sure that they saw it.

Or when she reads a book to her bunny with exactly the same intonations Babette uses when she reads the book to her daughter. Or when he holds your hand while you take a walk. Or when he tells you about the kids in his class at school. Or when she conducts an orchestra in music class.

Or when he needs a hug because he's scared. Or when she reaches out to a little kid in the park. Or when she beams with pride when she shows her mom and dad her art work. Or when he offers to share his Halloween candy with his brother and sister. Or when she climbs onto her mom's lap pleading for just one more book.

"The list goes on and on," Babette says.

"There's just nothing better in the world."

The Northrop's have done volunteer work for non-profits in Guatemala and plan to make many more trips to do more of the same as the years pass. Like many parents who adopt, Babette has done her share at adoption fairs and spent hundreds of hours counseling other couples through the decision and the process.

"We want to do whatever we can," she said, "to help more potential parents create forever families."

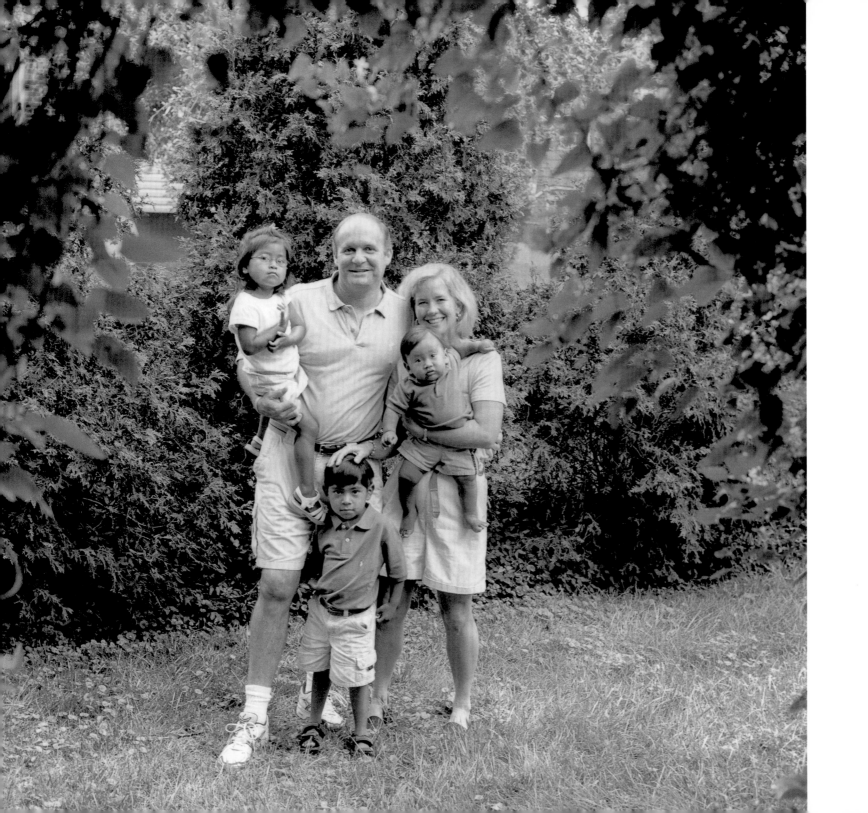

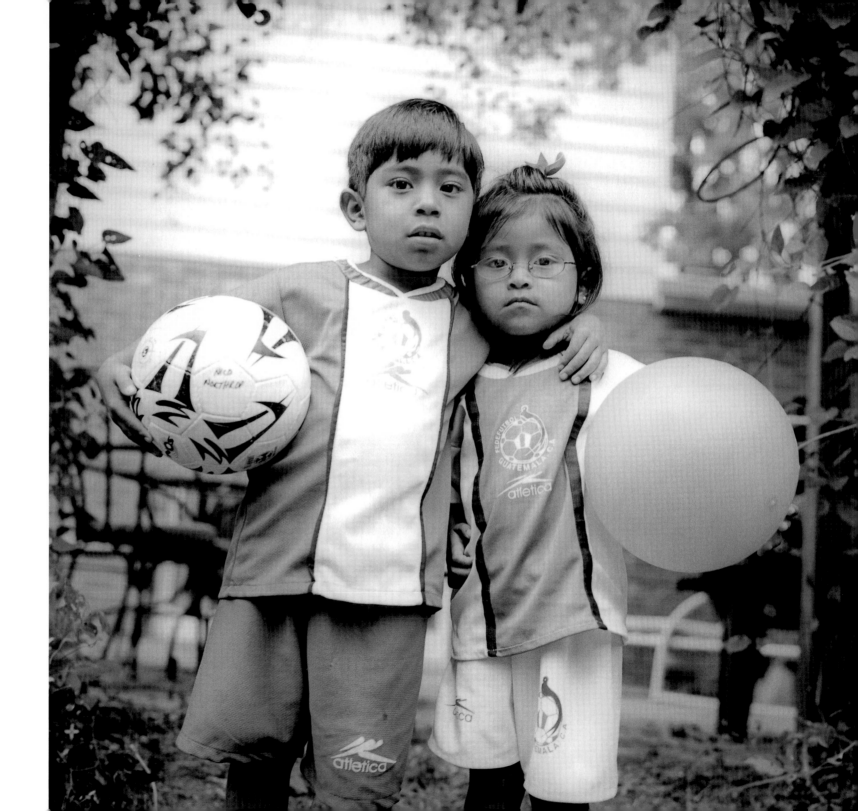

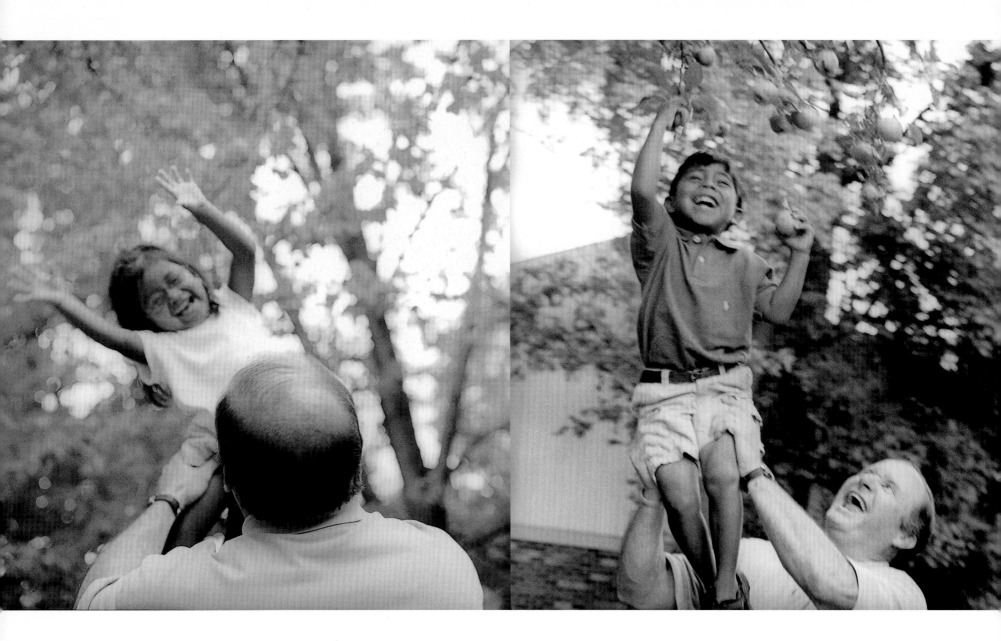

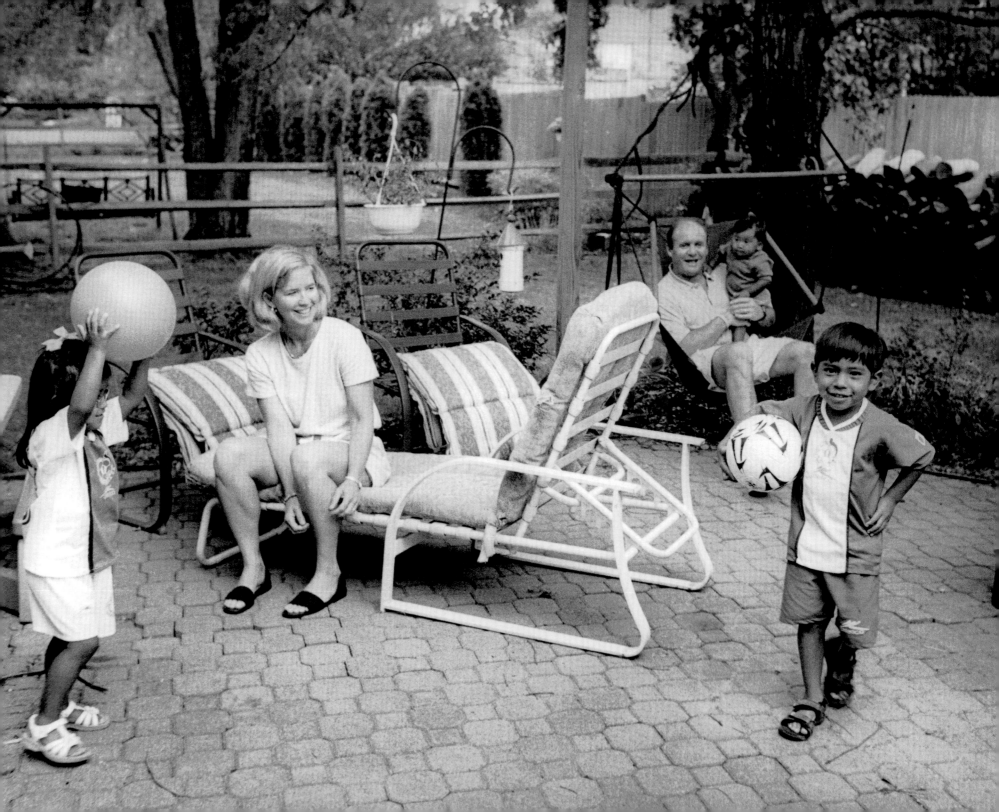

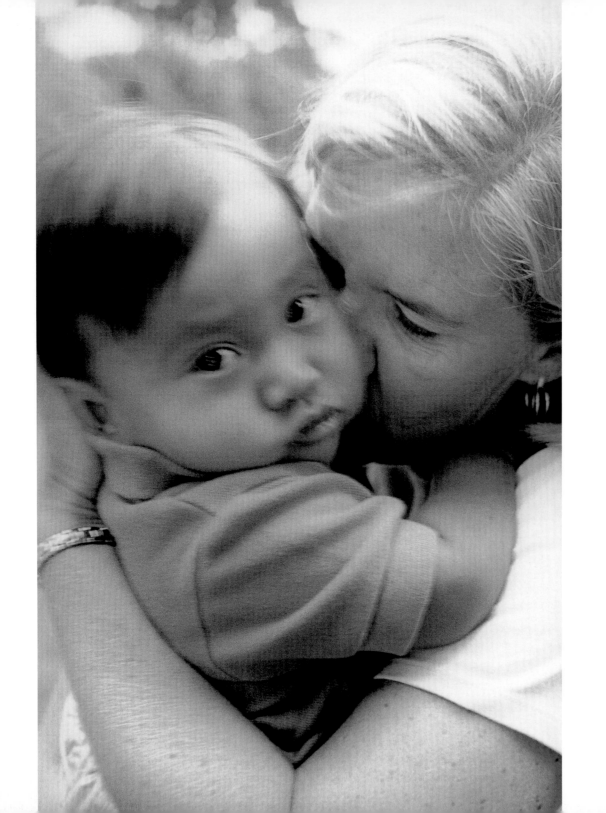

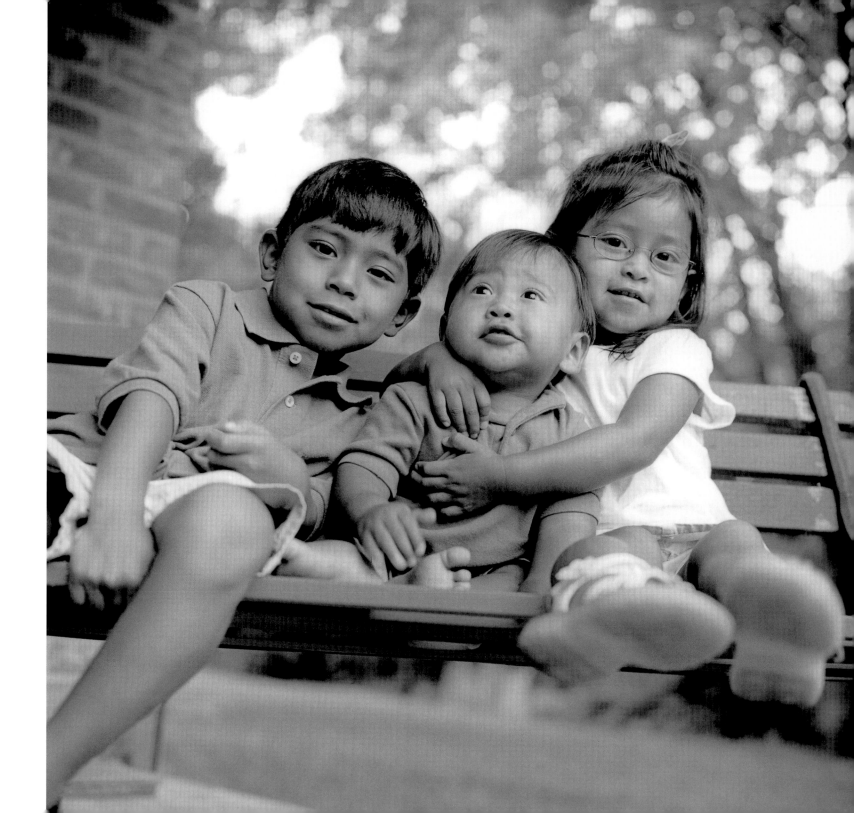

The McLaughlin Family

Introducing the McLaughlins:
Geralyn, Matthew, Thomas, Maria

The McLaughlin family consists of Geralyn and Matthew; their eight-year-old, biological son, Thomas; and one fiery two-year-old. Her name is Maria, and she was born in Guatemala.

Mostly, Maria is happy. She is energetic and curious, but will sit still to read a book, fiddle with a puzzle or follow the adventures of Clifford or Curious George on the tube. But when something runs counter to Maria's wishes, you'd better watch out!

The dinner table is the most dangerous place. Maria is quick to grab anything within reach. She reminds the rest of the McLaughlins of Elastigirl from *The Incredibles* because her arms seem to have a strange ability to stretch farther than anyone anticipates. And once Maria gets a hold of an object, it can become airborne instantly. She throws food, sippy cups and just about anything when she is the opposite of delighted. She also has developed an amazingly accurate aim, which in turn has caused Geralyn, Matthew, and Thomas to develop speedy reflexes.

Because of Maria's active temperament, the McLaughlins don't go out to eat or attend certain events as much as they once did—although they expect that to change. Lately, in fact, they've seen some subsiding of her legendary temperament. But to be fair, Maria's

lively nature keeps the rest of the McLaughlins alert and laughing. They've come to appreciate that with her around, no moment is dull.

Something else about Maria: She is very bright and quite physical. Just the other day, she taught herself to do somersaults. She's a talker, too. She is drawn to any kind of telephone and often pretends to call her dad. She's always surprising her parents with new little bits of language. She repeats just about every word she hears, good and not so good. Geralyn has had to watch her language, especially when she's driving and someone pulls out in front of her or something.

In addition to linguistics of various sorts, Maria loves to dance and sing and play and climb anything. She is also a runner, a jumper, can kick a soccer ball, and often wrestles with her brother over his toys. Maria has a bright beautiful smile and a strong life force, both of which are obvious to anyone meeting her for the first time. As a result, she attracts a good deal of attention and well-meaning questions and comments. Geralyn has observed that people who get to know her find themselves opening their hearts in ways new to them. "Right now, all of our lives revolve around Maria," Geralyn says.

"We have learned patience and acceptance of another personality type thanks to her. It's perhaps been easier for me since I have one of those Latin temperaments, which fortunately has mellowed through the years. We look forward to helping her understand her strengths and weaknesses so that she can live her life to the fullest. We cannot imagine our lives without her.

"She brings more color and passion to our lives than we could have dreamed."

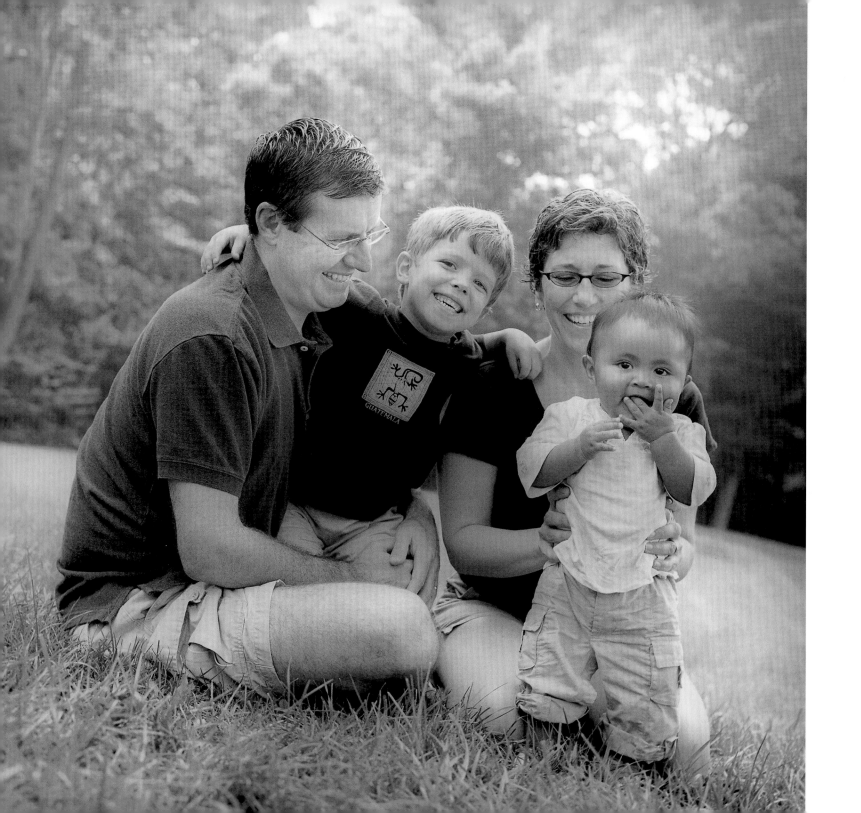

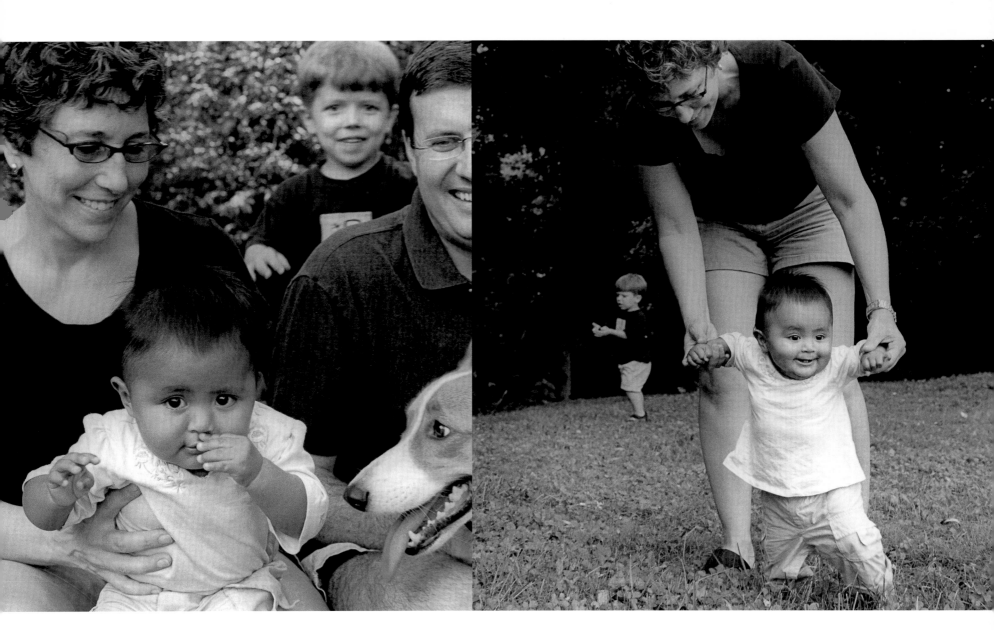

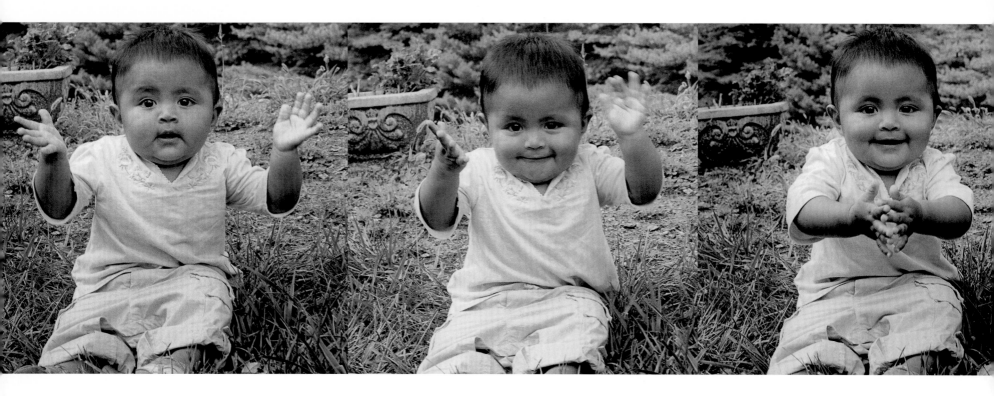

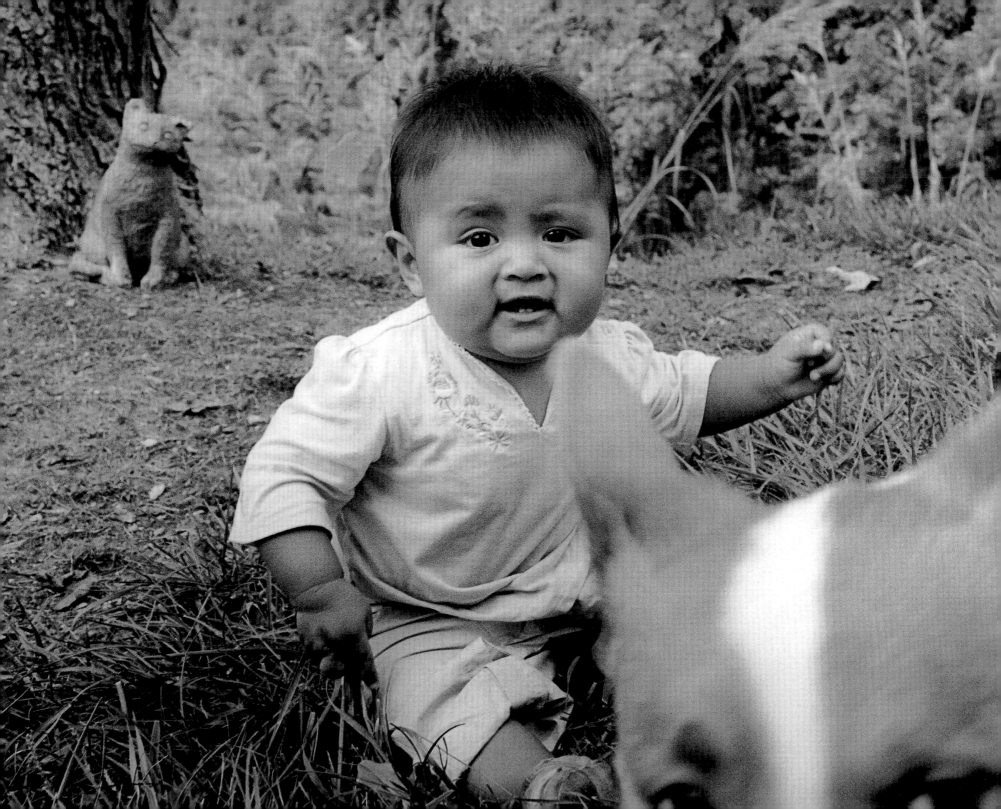

The Larkin Family

Introducing the Larkins:
Jane, Bob, Brian, Jozsef, Emese

On a snowy December day, Bob and Jane Larkin found themselves in a tiny village in the mountains of Transylvania. The foster home was humble, with no running water, but it was clear that the boy, Jozsef, had been cared for lovingly.

The moment Jozsef was in Jane's arms and their eyes locked, they arrived at a mutual understanding: He was hers, and she was his. It was just as true with his new father. Even now, eight years later, just how it happened is a bit of a mystery to Jane and Bob. All they know is that the power of the bond between them and Jozsef was instant and as profound as anything they had ever known.

Emese came along six months later. It was a coincidence that she was in a foster home in the same village. Like Jozsef, she was two years old. And like Jozsef, she has been Bob and Jane's child from the moment they met.

Emese had an enormous smile and chattered in Hungarian, not Romanian. She remains bubbly and curious about everything. She talks in exclamation points! This past year, she was picked to sing a solo at the school Christmas concert. The teacher asked Jane to dress her in an angel costume. Seventeen years earlier, Emese's big sister, Kerry, was supposed to sing a solo at her Christmas program. Kerry's grandmother

had made her an angel costume for the occasion, but Kerry never got to wear it. She died after a short illness, at the age of ten.

As far as Emese was concerned, there was no question she would wear her big sister's angel costume. She and Jozsef have both talked about how Kerry gave them their first kiss in heaven. In every family picture Emese and Jozsef have ever drawn, there's Jane and Bob and their big brothers, Sean and Brian. Hovering over all of them is Kerry, always an angel and always an important part of the family.

Jozsef makes his parents crazy and laugh at the same time. He has a knack for picking up different ways of speaking. When he comes home from visiting Jane's family in Mississippi, he talks with a southern drawl. He recently began building a tree house in an apple tree, complete with a sign specifying who's allowed and who isn't. Jane and Bob don't want him to grow up too quickly, but can't wait to see what he does with his life.

Emese has the gift of compassion. When the family drives through the heart of the city, she wants to bring every homeless person home with her. It hurts her to see someone unhappy. If an idea occurs to her where she might help someone, she does it. She has had her shiny black hair cut once already to be made into hairpieces for cancer patients through Locks of Love and can hardly wait for her hair to grow out so she can do it again. Jane and Bob imagine Emese will mother her way through her life.

None of this is to say the Larkin kids are perfect because they aren't. They battle over who takes out the trash, who gets the bathroom first and who gets to sit in which car seat.

"Chaos reigns most days and sitting on the steps occurs daily, but we are truly a family through and through," Jane said.

"Our differences make us stronger, and our similarities are endless. I wish I had the words to express what a joy it is to adopt a child. You don't have to be rich or young. You just have to love unconditionally and without reservation.

"So many children are out there waiting for their own mama and daddy."

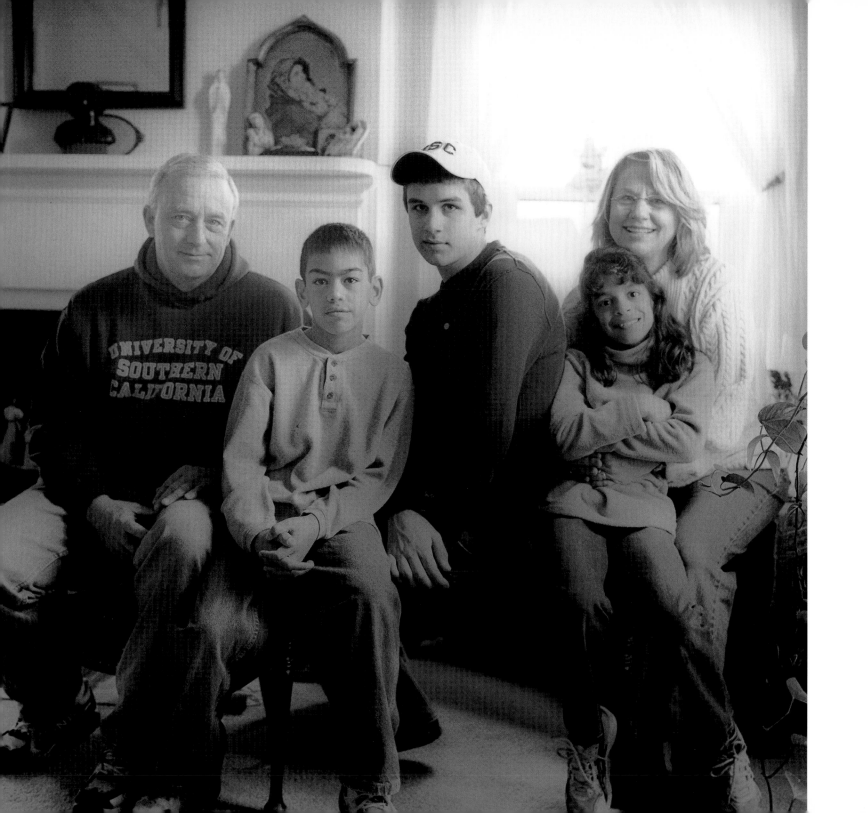

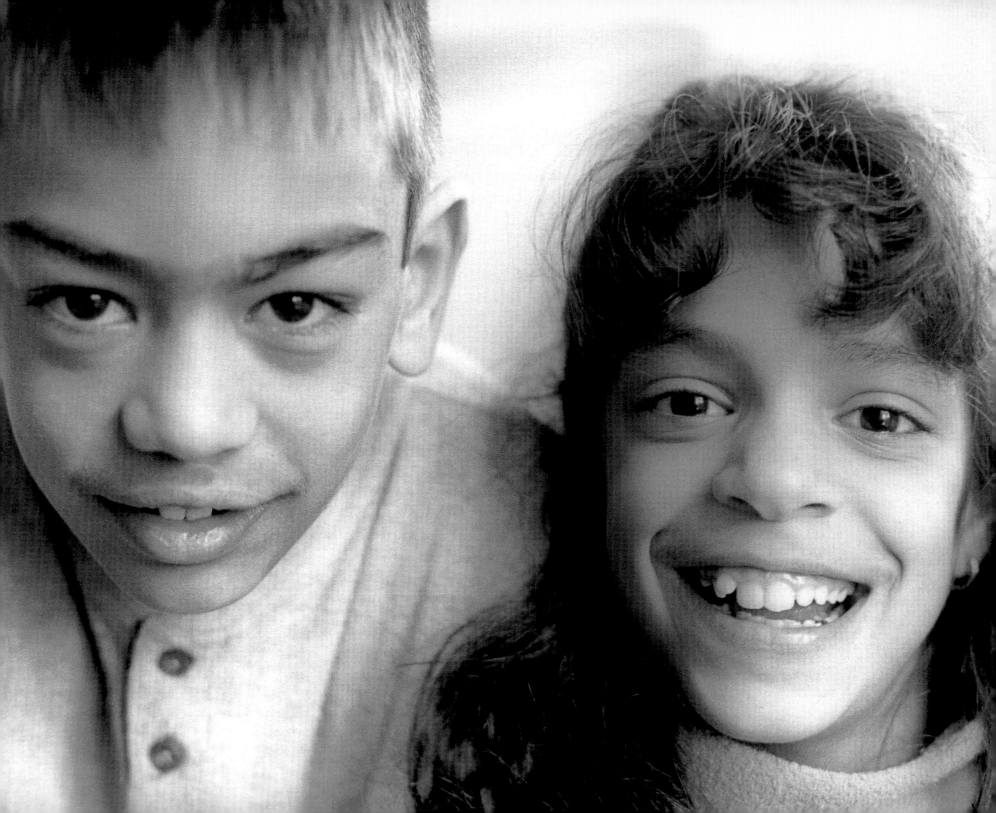

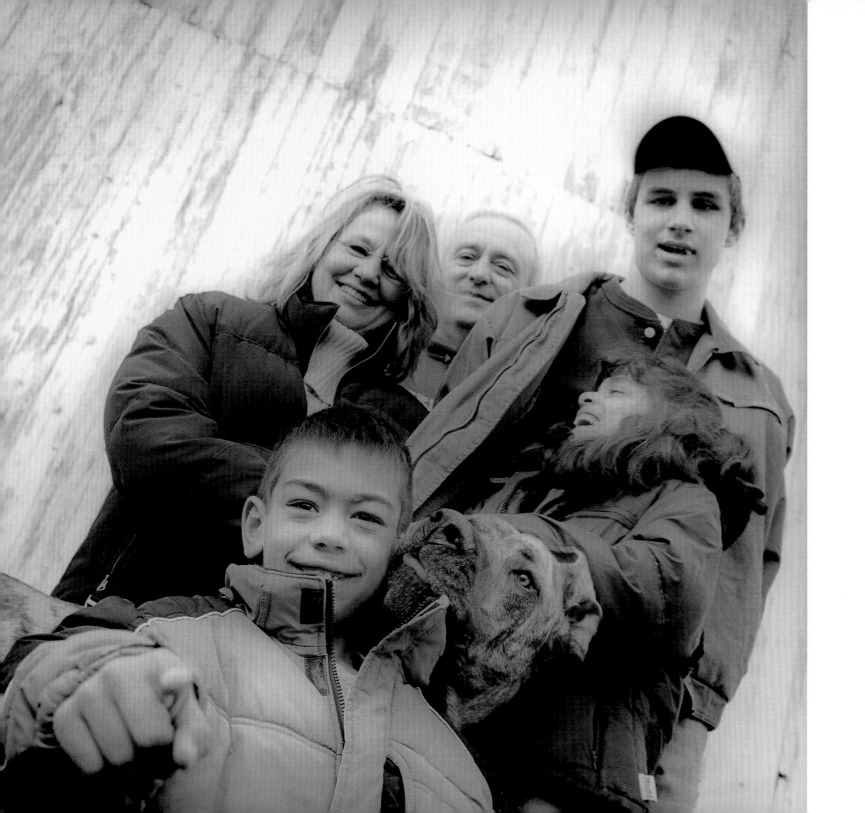

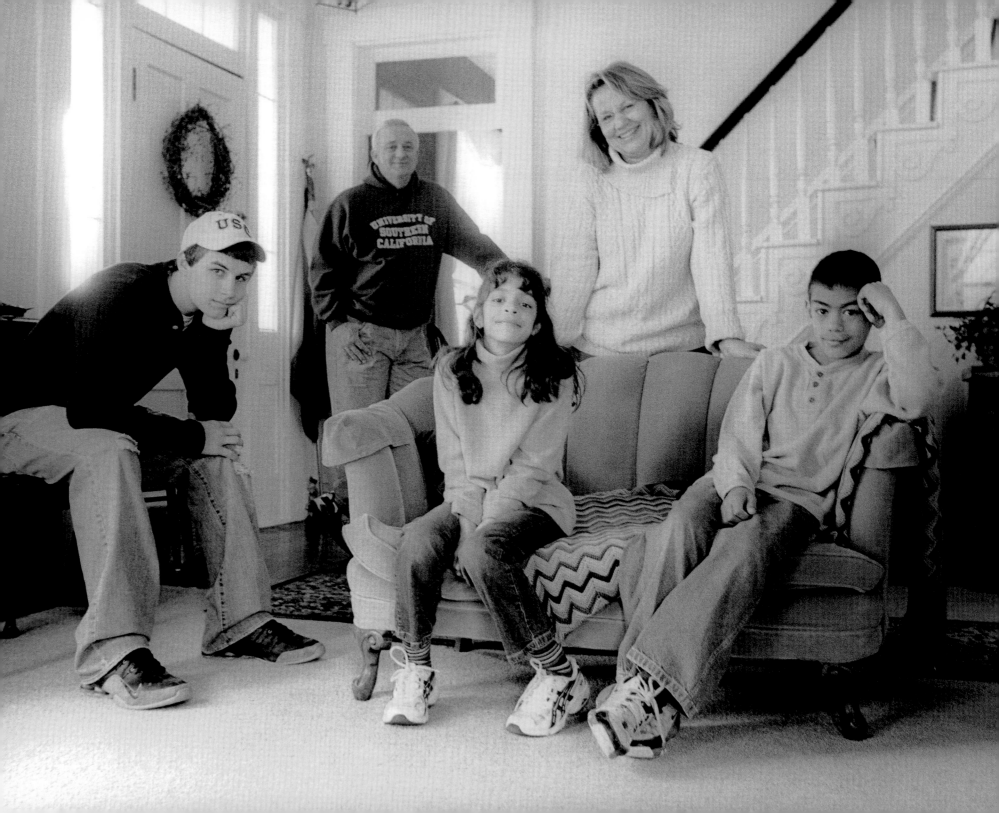

The Wallis Family

Sydney and John Wallis love the color that graces their home. They love all the different sounds of laughter that come from all corners and all the energy that flows through the house, even when it seems to rush at them at hurricane velocities.

These are the things that remind them constantly how their children came from such different places and such painful pasts—and that, given the chance to flourish and the encouragement to explore, each has become his or her own one-of-a-kind, filled with hope, a promise waiting to be fulfilled.

Their oldest, Jacob, 21, once supposed that growing up a Wallis had given him a pretty good sense of how God meant the world to be—a place where everyone is accepted and loved, no conditions, no matter what.

After Jacob, the Wallises had three more biological children, Evan, Hadley and Bailey. Their first adopted children were Noah and Cecilia, who were born in the U.S. Then they adopted Micah and Isaiah from South Africa in 2001, followed by Milena, Kasey and Solomon from Ethiopia in 2003.

Two-year-old Quinn was a biological child, who came as a huge surprise and a welcome miracle. Next came Simeon and Anna in 2005.

If all goes as planned, three-year-old Seth is expected to arrive from China around the first of the year. Put them all together, and the Wallis family has enough kids to field a baseball team and a pair of tennis doubles teams with enough left over for a spirited tug-of-war.

Each has a different role. For instance, Isaiah is the comedian—he has a 100-watt smile and a blood-curdling screech. Solomon is the peacekeeper, always positive, always looking on the bright side. Milena is the little mother, the one with a heart bigger than her mind can handle. Anna is the precocious one. She likes to stir up trouble and seems to think of herself as a little princess.

Micah is a mommy's boy but likes to push everyone's buttons including Sydney's. He is determined and strong-willed. Kasey has a lively imagination and is the one who rallies everyone for activities. Simeon, adopted when he was 14, is the reserved one who prefers to watch and learn, although he is showing signs of taking on the role of helpful big brother. He is confident in some ways, shy and unsure in others.

Each has a different plan. Milena wants to be a doctor. Simeon wants to play professional soccer. Kasey would like to invent robots. Solomon intends to be an astronomer. Anna wants to be a runner.

Micah's plan is to be an astronaut and explore space. Isaiah wants to be a Christian. Noah wants to be a football player. Cecilia wants to be a singer.

When you think about it, that's a whole lot of ambition for one family. Then again, it's a whole lot of family. That's where it stands with Sydney and John and all the rest. Fifteen kids and holding. At least for now. At least for the moment.

Sydney has this to say on the subject: "Once you've seen the need and the children and you feel called to do something, you can't turn back. We believe that, as long as we can continue to love, provide and care for children God brings to our hearts, we will bring them into our home.

"I think the most amazing part of our story is the way the kids bring each new sibling into the fold. There's no question about the new one belonging. The child comes home and everyone joins in playing, helping, sharing and loving the other. In this way, we all grow."

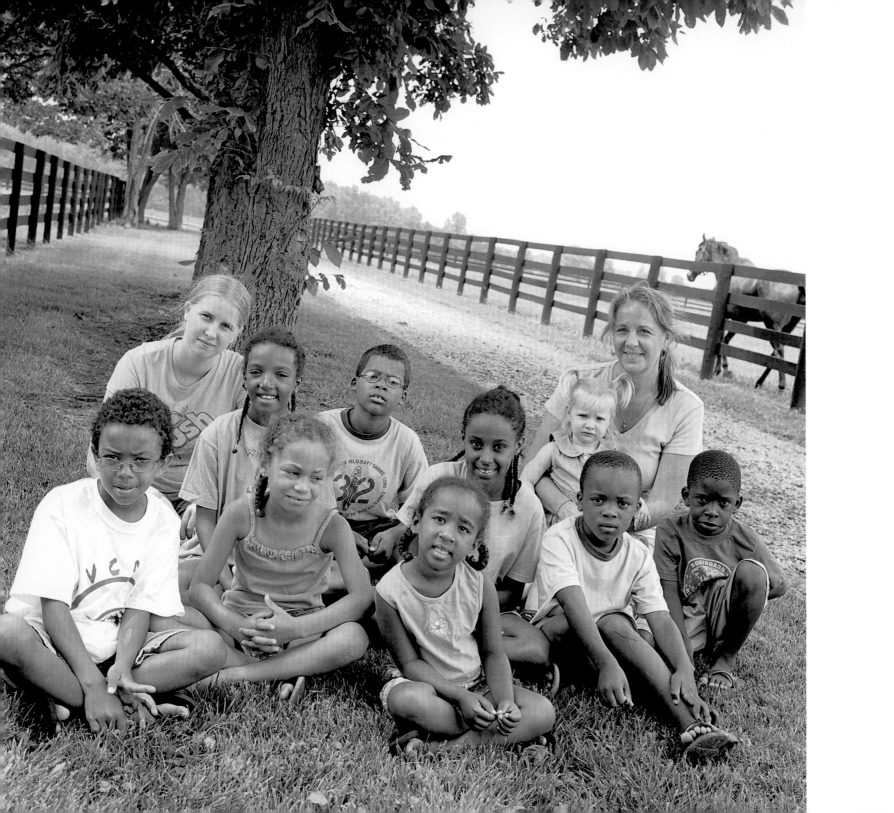

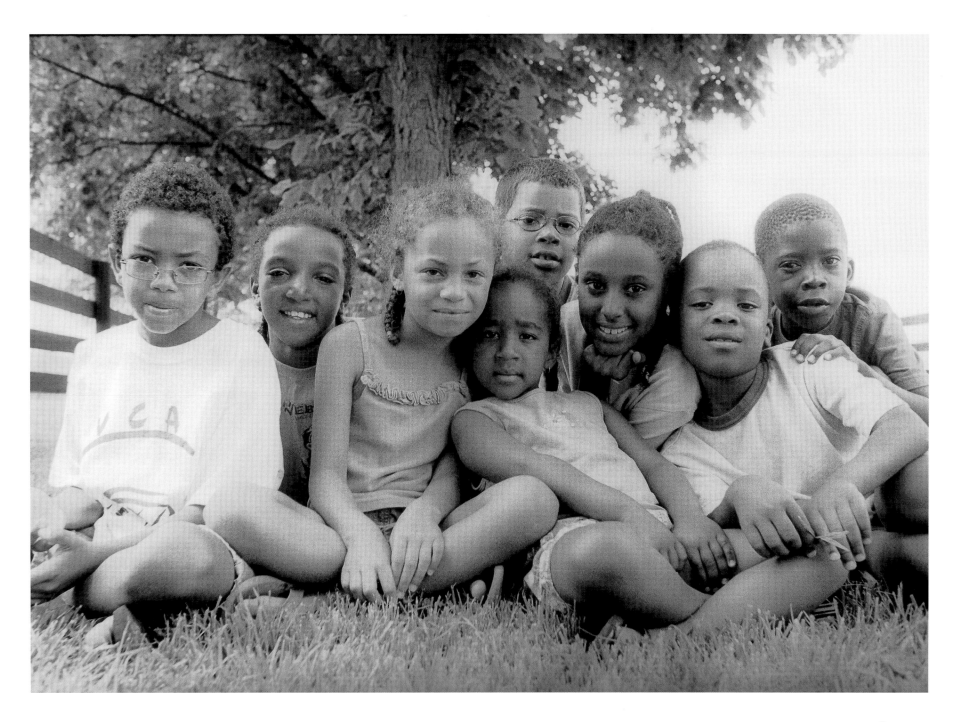

The Sparling Family

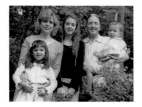

Introducing the Sparlings:
Karen, Paul, Ashley Marie,
Natalie, Kenneth

From time to time, five-year-old Natalie Sparling and her four-year-old brother, Kenneth, need a bit of extra reinforcement — maybe a hug that holds on a little longer than normal or a few words of reassurance.

At such times, their parents Karen and Paul sense that they need to be reminded how much they are loved. They need to hear that they are part of this family for good and that nothing about that will ever change. The children have a way of sending out faint signs of insecurity, and their mom and dad have a way of picking up on them. Maybe with time, the sadness of their first few years of life will fade. Maybe they won't. Either way, Karen and Paul will be there for them.

Natalie is five years old. She's all girl. She looks forward to her dance lessons and has no fear when it comes to jumping into the pool. She loves to play mommy and gladly helps take care of her brother when he needs comforting. When Karen and Paul were introduced to her at the "baby home" in the Russian city of Ufa, on the western slopes of the Ural Mountains, she struck them as shy, quiet and demure. It didn't take long for that to change.

Kenneth is eight months younger and developing into an all-American boy. He is both inquisitive and physical, always looking to play rough and tumble with his dad. You can see him modeling his father in the way he imitates his dad when he's working around the

house, doing one job or another. Kenneth also has the gift of patience and can spend hours working on puzzles that would quickly become boring to Natalie.

Of the two, Natalie is the more sensitive one. She is quite perceptive and likes to show off to her family and friends about new things she learns in school, in dance class or in gymnastics. Like her fifteen-year-old sister, Ashley Marie, Paul's homegrown daughter, Natalie has a tendency to sleep late.

Not Kenneth. He bounds out of bed early, usually around 5:30 every morning. He is one of those boys naturally drawn to be where the action is. When he can put himself at the center of the action, so much the better. His pre-school teachers often remark about how eagerly he interacts with all the other kids and how he likes to welcome the parents when they arrive with a wave and a robust "Hi!"

There is a gentle sweetness to the way Natalie and Kenneth look after one another that touches their parents' hearts. Unless someone told you, Paul says you'd never guess they aren't biological brother and sister. Apart from having a similar look with similar physical features, they're bonded in some ways more than most siblings.

Perhaps it's not surprising when you consider they were both brought out of the "baby home" together, flew to Moscow together, stayed in the hotel together and flew to the U.S. together. They even shared a bedroom for the first three years they were with their new parents. To this day, with their separate rooms and separate interests, they continually check on each other regularly.

Natalie and Kenneth have added a welcome sort of kid chaos to the Sparling home. Just by being who they are, they have helped their family to a clearer understanding of what really and truly matters. Because of Karen and Paul, they went from having no one to having not just a mom and a dad and a teen-age sister—suddenly they had an extended family of more than 50 people, all of whom love them completely.

Pretty cool. In return, Natalie and Kenneth are pleased to hold up their end of the bargain. So if they send out signals from time to time that they need a touch of reassurance, their mom and dad are happy to oblige.

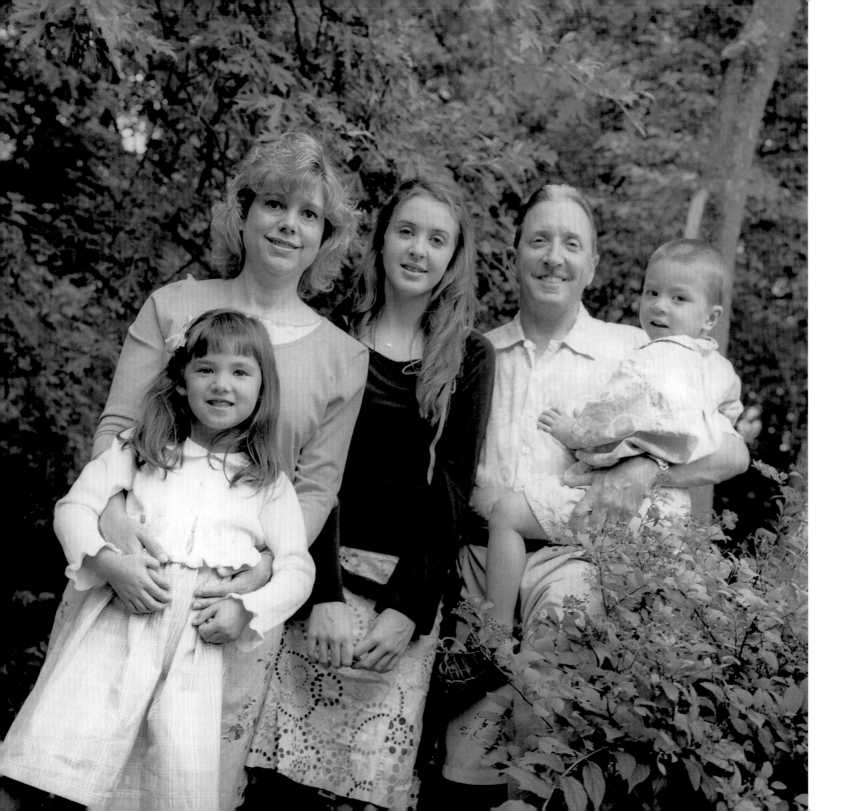

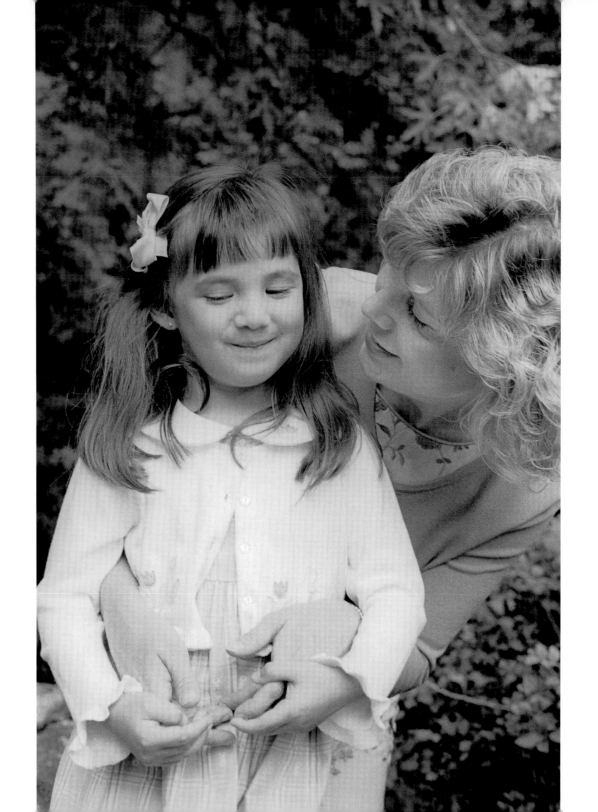

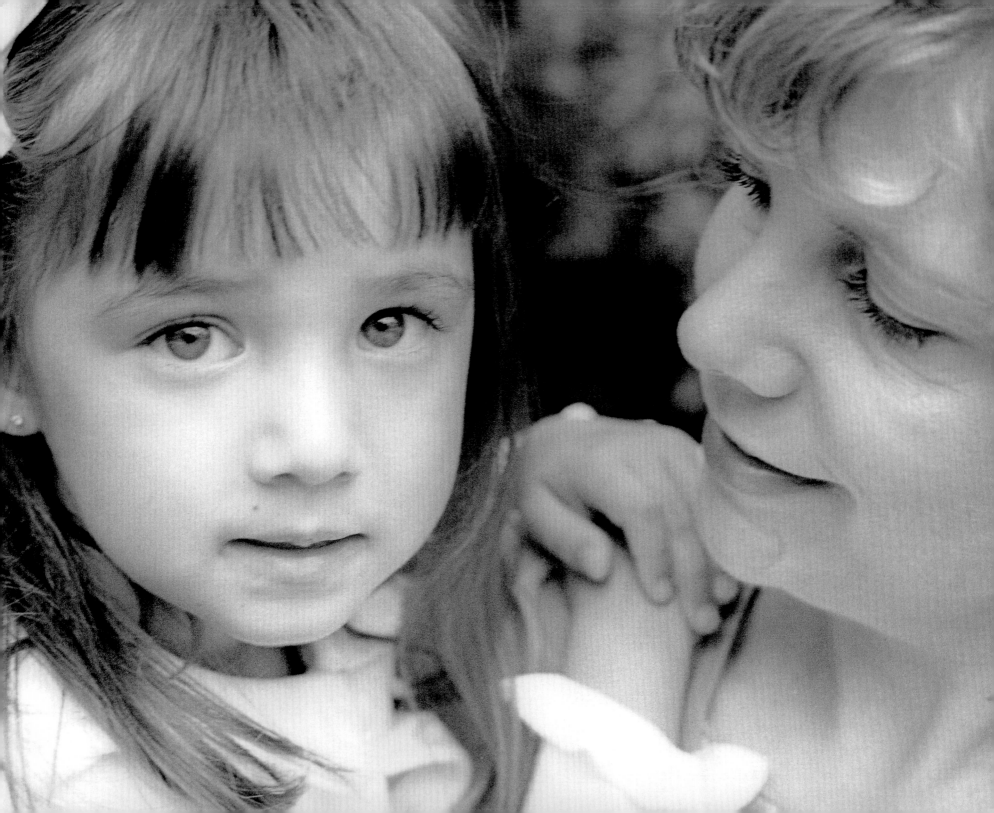

The Boerner Family

Introducing the Boerners:
Becky, Jim, Christopher,
Nathan, Susannah, Jonathan, Eliana

Nathan Boerner loves science and art. In particular, he likes the art of origami. His parents, Becky and Jim, have dozens and dozens of cranes, frogs, flowers and stars he has made from folded scraps of bright colored paper. They think it's pretty amazing, really, considering Nathan has only one arm.

His brother, Christopher, is drawn to music and to reading and to pretending with knights and castles. He likes learning about animals, too — he collected crickets and discovered that only male crickets sing. He also enjoys gardening, and the plants do well for him. He has a sweetness that melts his mother's heart.

Susannah likes to draw and leave notes for her mother to find on her bed. She seems to find friends wherever she goes. She especially loves little children. She will play for hours with her younger brother and sister, making up pretend games for them. When she grows up, she wants to be a girl who rides horses. Becky is still looking for a newspaper ad that reads, "Wanted: Girl who rides horses. Apply here."

Christopher, seven, was their first. He was born in the Marshall Islands. Nathan is from South Korea; Susannah is from China. They're both six-years-old and only six weeks apart. They told Becky once that they were twins; they believe in their hearts that they are. When someone asks them if they're twins, they say, yes, just not identical.

But they do have their own twin-like language. Susannah brings out a goofy part of Nathan that few others can, and Nathan is able to explain things to Susannah that no one else can.

Before Christopher came along, Mother's Day was one of the worst days of the year for Becky. She longed for a family. As the eldest of the Kayes' family, with its nineteen children (noted elsewhere in these pages), she was accustomed to a house with lots of kids. It so happened that Christopher arrived on Mother's Day in 1999, changing the holiday forever for Becky. Now it's one of her favorite days because it reminds her of how amazing it is to be a family.

Becky and Jim chose to follow their hearts, and their hearts led them first to the Marshall Islands and Christopher. Then their hearts led them to an adoption listing where they saw Nathan's photograph. They fell in love with him and knew he was meant to be their son. They also saw Susannah's picture on an adoption photo listing and instantly felt connected to her. It was as if they knew she was missing from their lives.

Once they had adopted three, Becky and Jim were surprised in short order to have two biological children. Jonathan is three, and Eliana is one. Becky smiles when she tells people she prayed for children and God answered. Now, she tells them, she prays for money.

This Thanksgiving, after saying grace at dinner, Becky's brother, Brian Kayes, turned to her and said, "Thanks for finding me." It was all Becky could do to hold back the tears, realizing how grateful he was to have a family. Years earlier, Becky had seen Brian's photograph on her adoption agency's website. She forwarded the information to her parents, Nancy and Joe Kayes, who decided to bring him into their family.

"My brothers and sisters have made me realize how important it is to grow up in family," Becky says.

"They helped form a grateful heart in me."

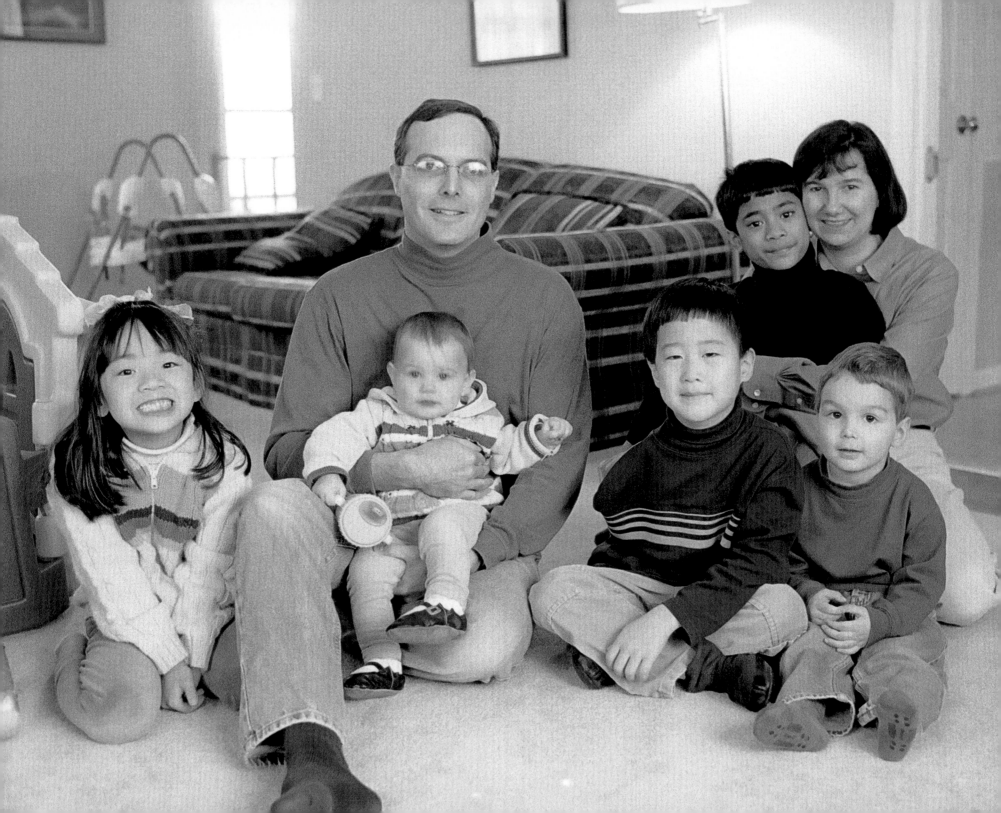

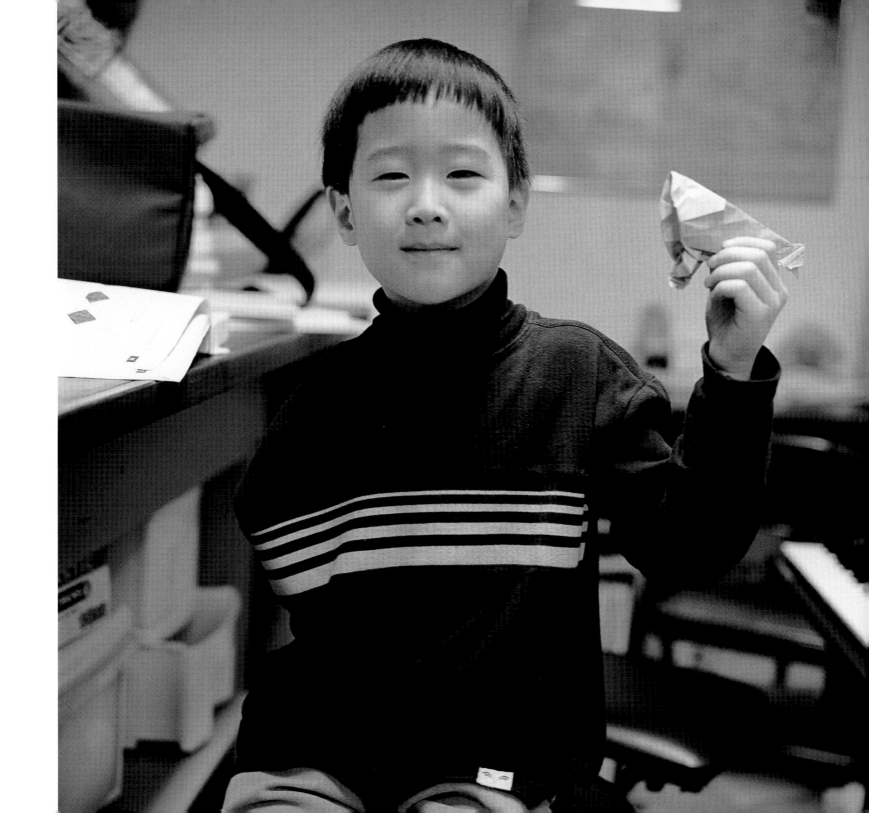

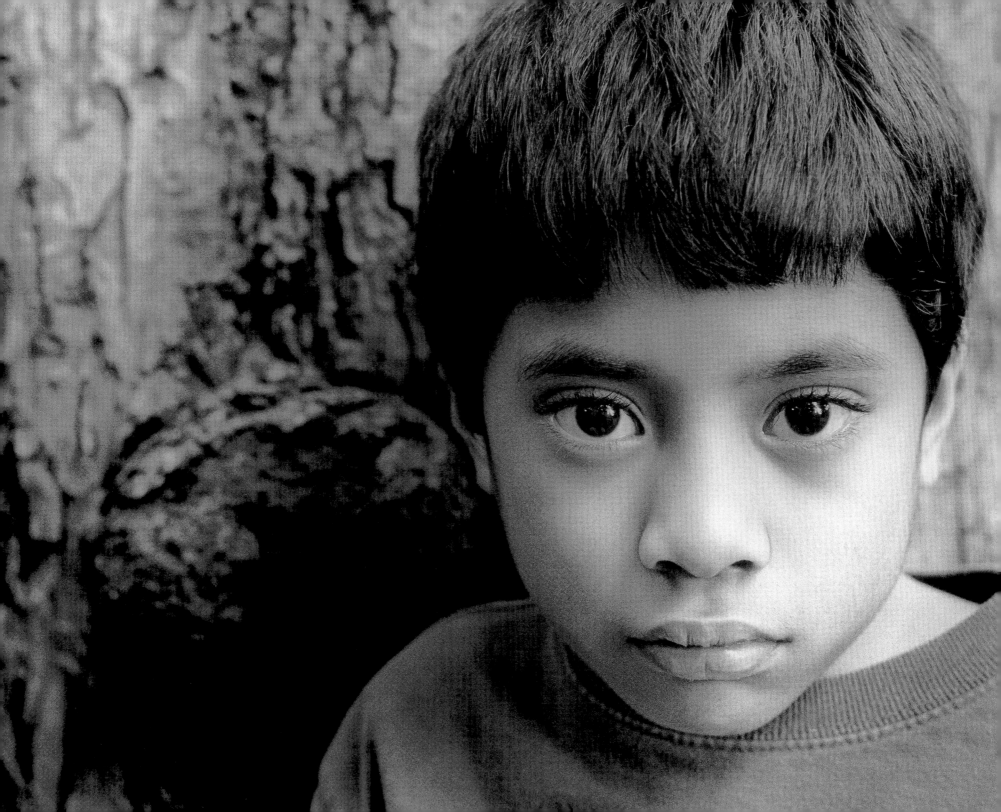

The Kayes Wedding

The occasion was the August 2006 marriage of WanYu Wang and Andrew Kayes, the third of Nancy and Joe Kayes' nineteen kids. WanYu and Andrew met in Los Angeles, where she is an electrical engineer and he was doing his residency in radiology at the UCLA Medical Center. WanYu graciously agreed to have the wedding in the Kayes' hometown of Cincinnati, given the sheer number of the Kayes family.

Take a look at this bunch — that's one family. Some live in different parts of the country, so it's not often they can all get together. Weddings are a good excuse. But even when they actually are all together, as they were at WanYu and Andrew's wedding, it's still hard to get them all together, simply because they are so many moving pieces.

This photograph was taken in the foyer outside the Hall of Mirrors in the Omni-Netherland Hotel in downtown Cincinnati. It was taken hurriedly, arranged and shot in not much more than a minute. Brothers and sisters were looking this way and that, trying to see at the last minute if anyone might be missing — and in fact, a couple were.

So while all nineteen sons and daughters were at the wedding and the reception, they weren't all in the same exact place at the precise moment this photo was taken. But when the shutter clicked, it captured an image that offers a clear sense of the scope, depth and breadth of a remarkable family.

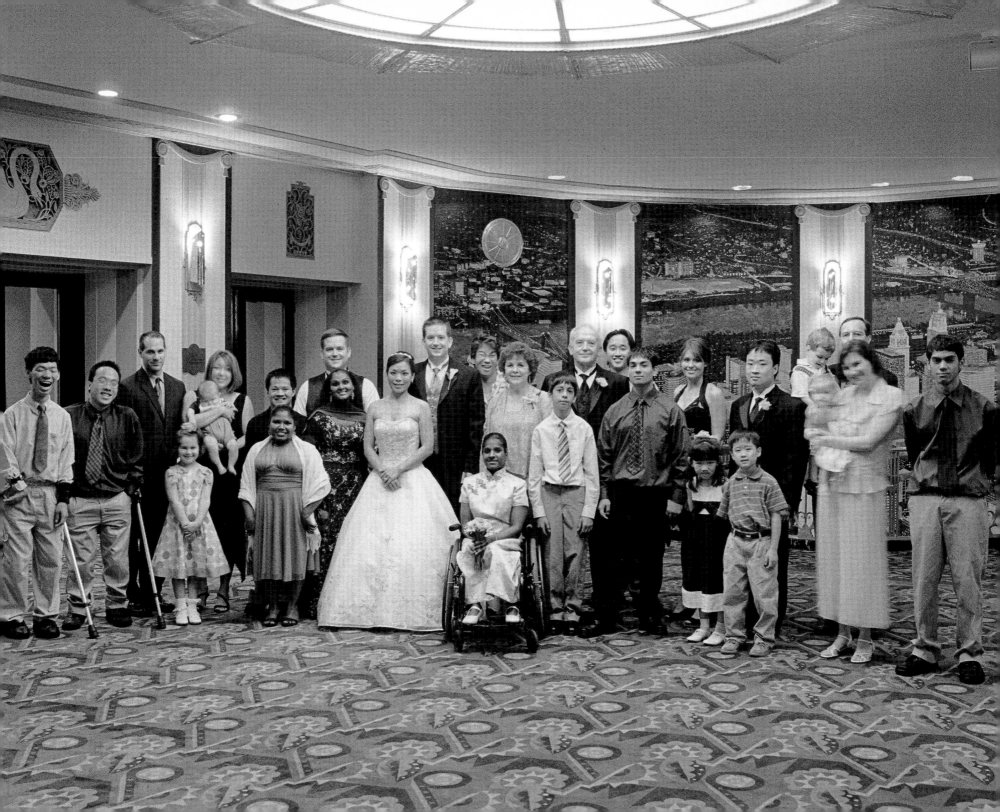

My Brother Marco

by Katie Davis

Guatemala.

In the lobby.

Waiting, waiting.

Waiting for the family

to walk through the door.

I can't wait to see him,

My Brother Marco.

They arrive.

We ride up the elevator.

We are in our room.

Zack and I

obediently wait in the other room.

We press our ears up to the door,

but get no response.

I wish I knew

what they were saying about him,

My Brother Marco

Soon I am in the room.

I take everything in.

All eyes are filled with tears.

Tears of sadness

tears of joy.

Holding that little baby

for the first time.

My Brother Marco.

Love Shines Through

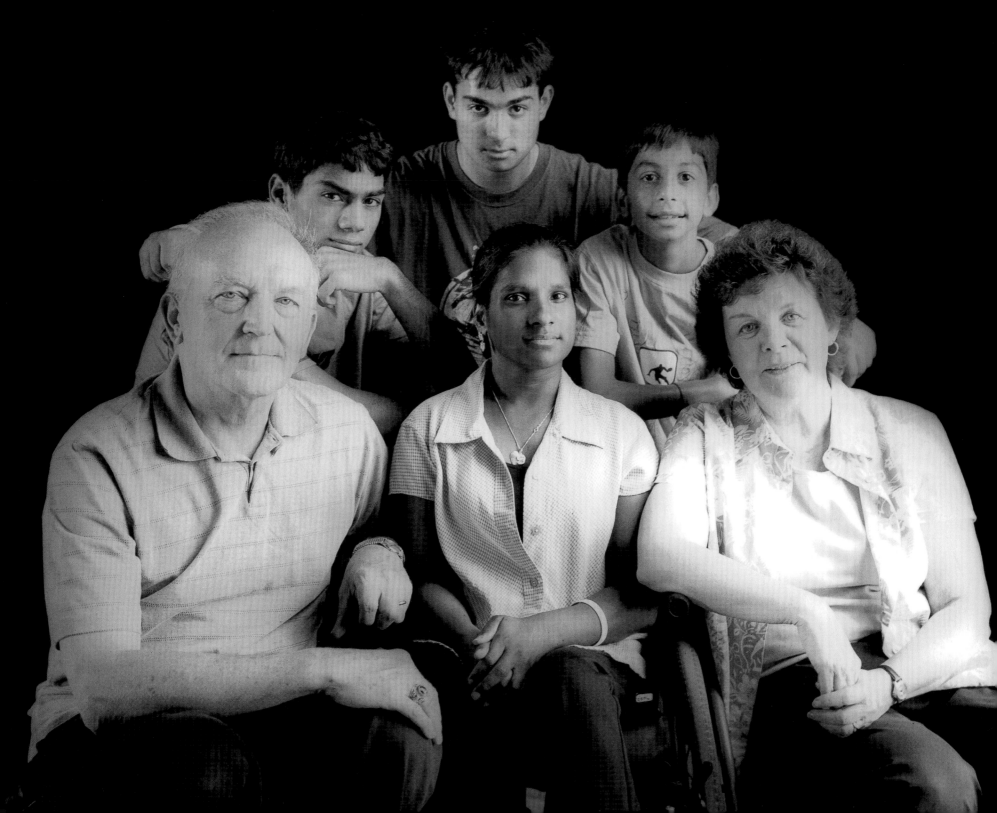

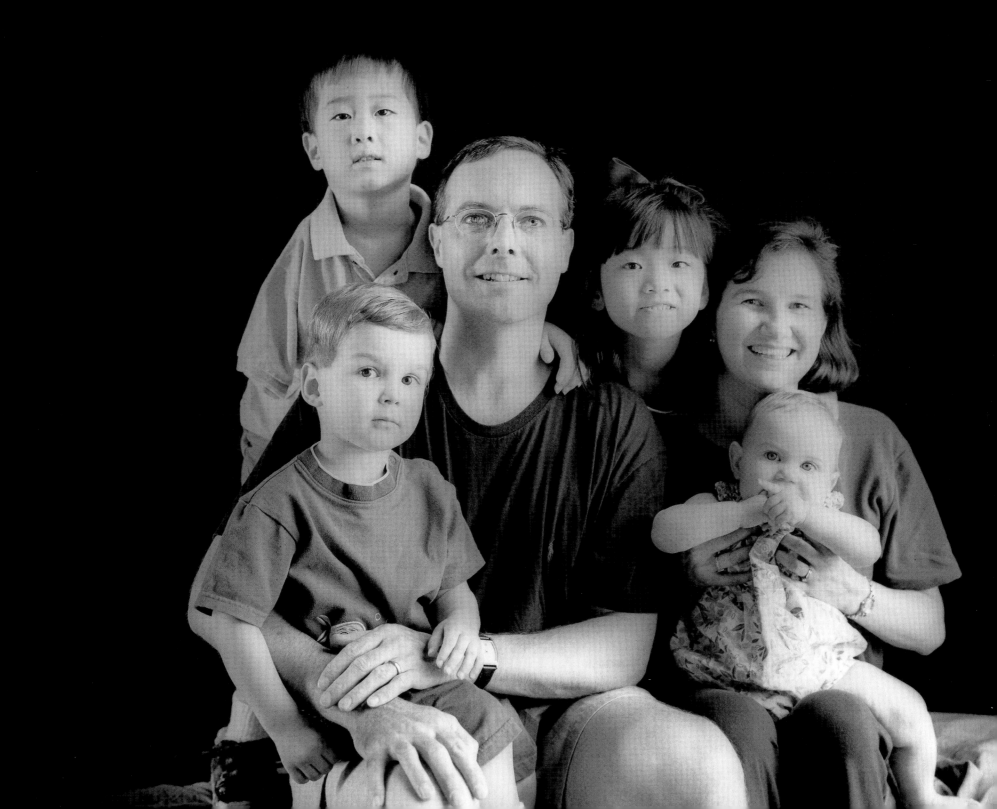

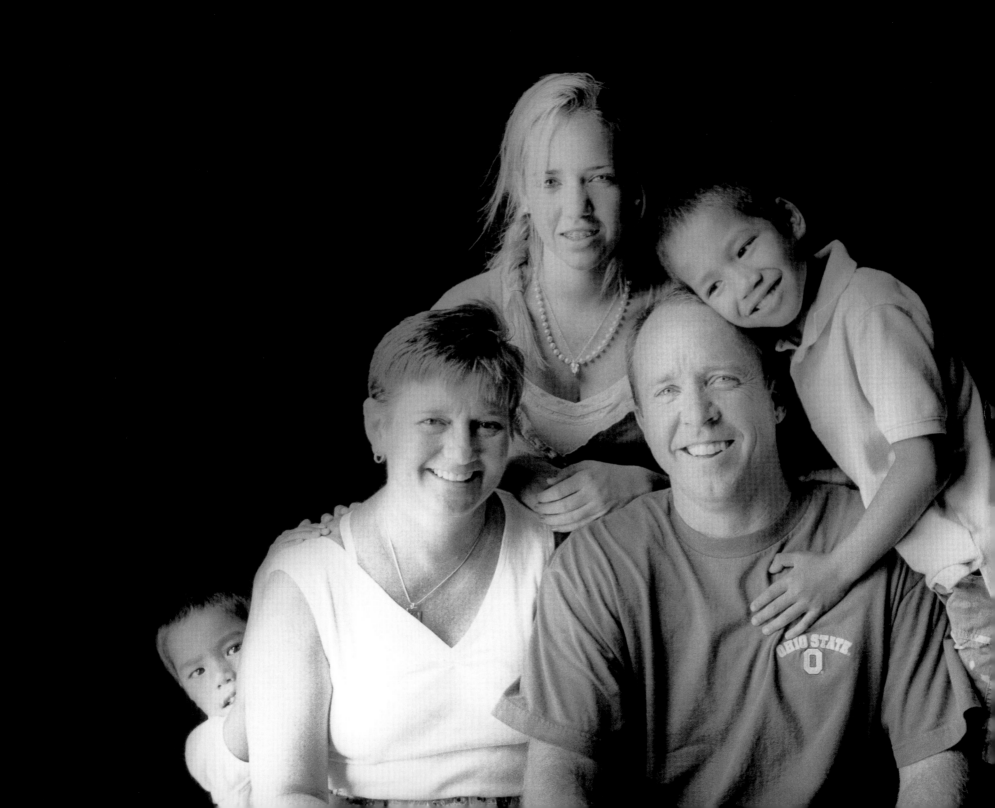

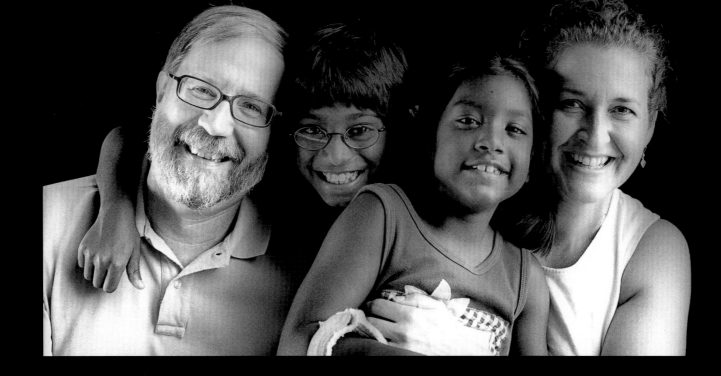

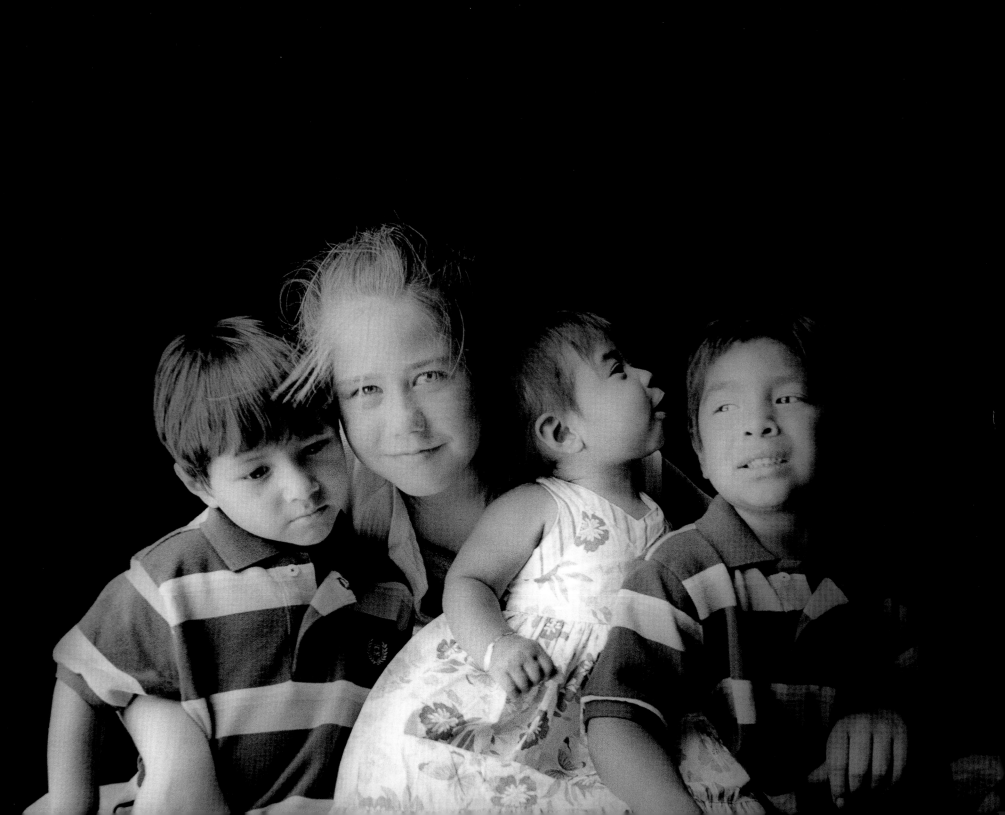

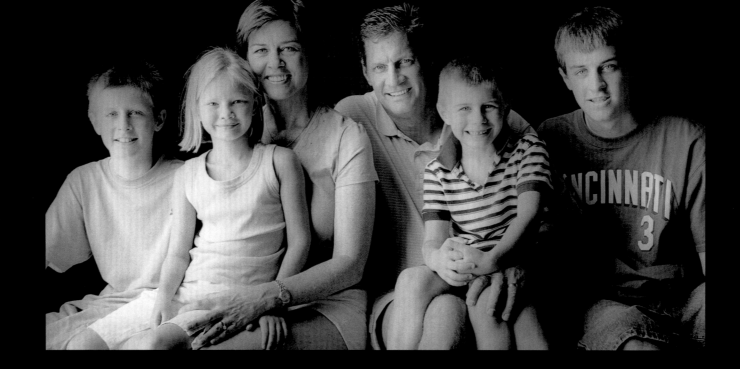

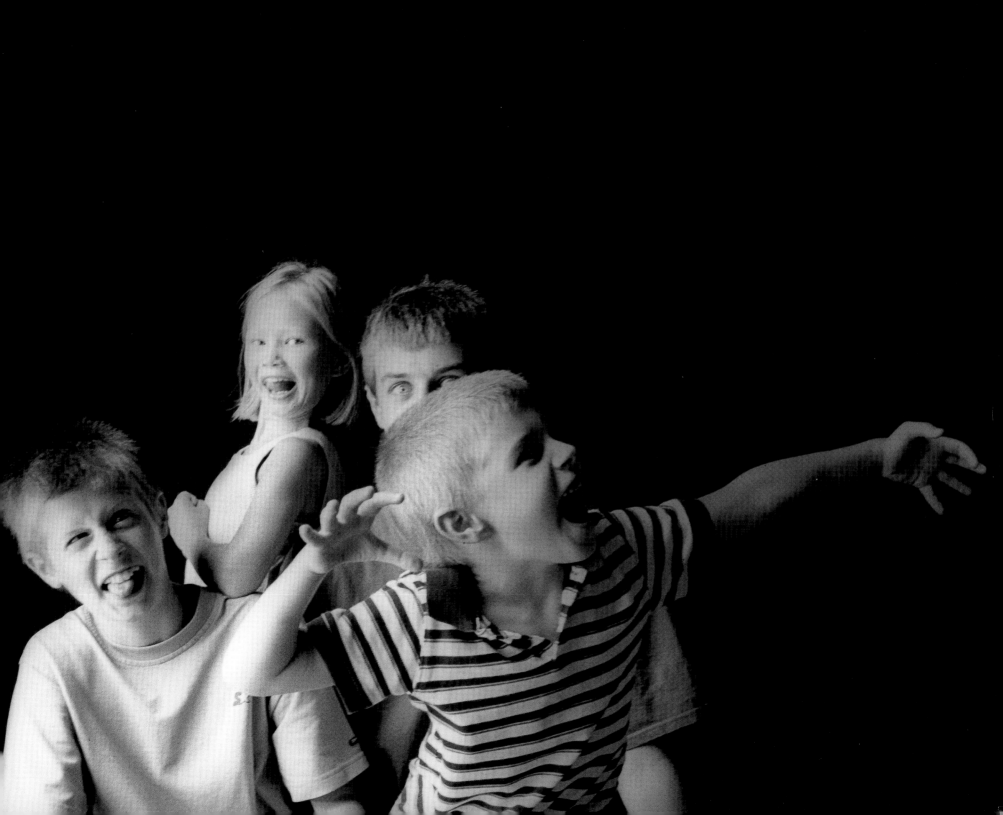

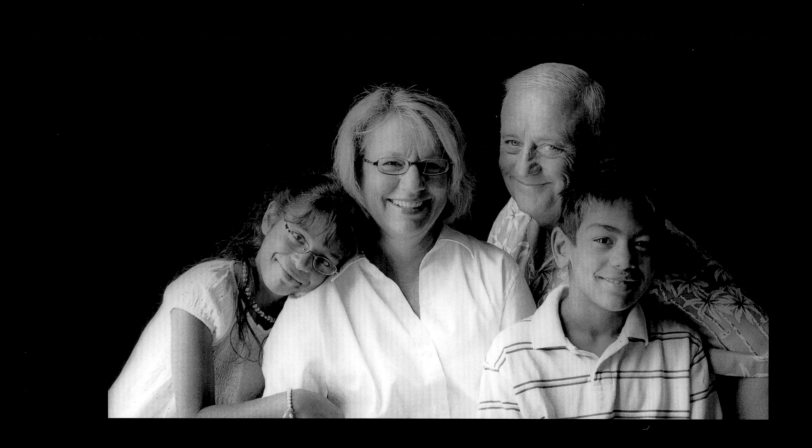

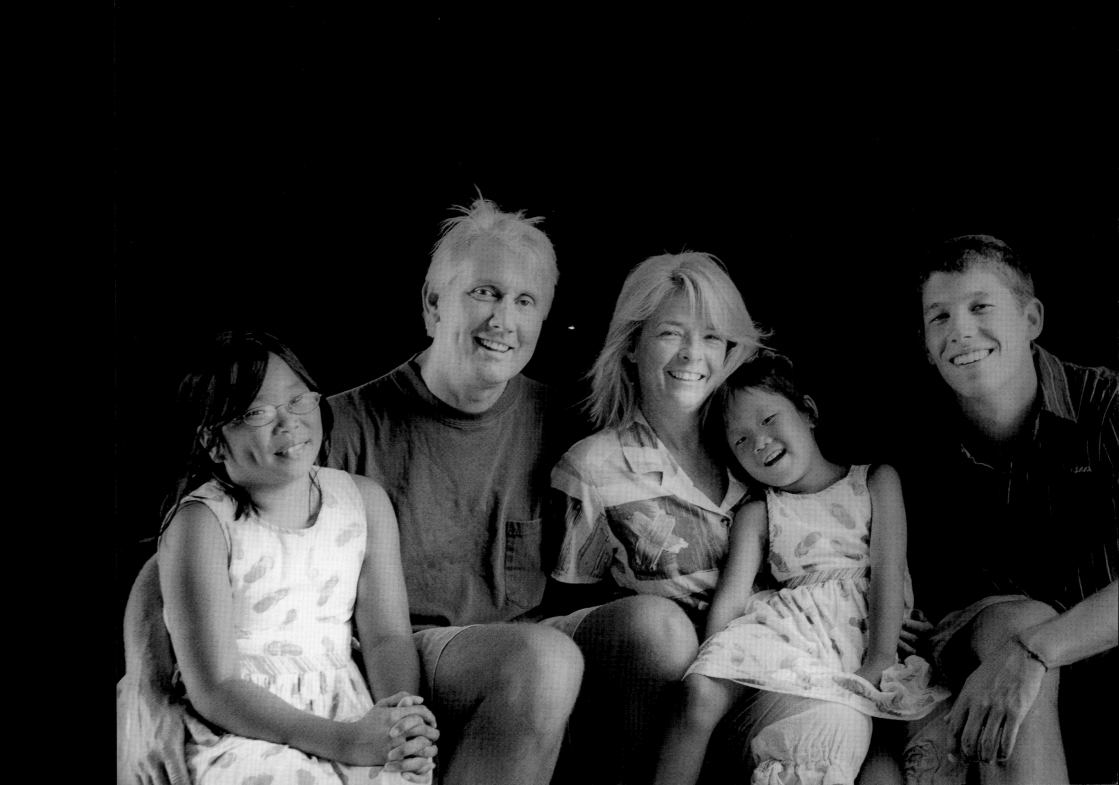

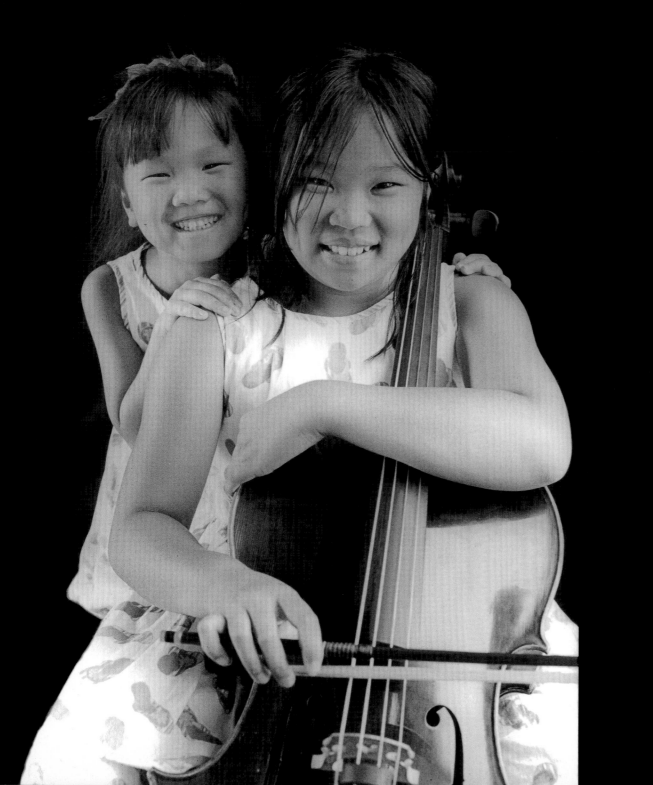

The Kayes Family

Introducing the Kayes:
Nancy, Joe, Zach, Sarah, Brian, Chris

A big family. That's what Nancy and Joe Kayes wanted. In the beginning, they thought big meant six or—who knew?—maybe even seven kids.

They had three birth children, then chose to adopt. They explored domestic options, but no one would talk to them because they already had the three homegrown kids. So they checked into international adoption and landed in Korea.

Barbie came home when she was six months old. Nancy and Joe discovered she had cerebral palsy. Barbie was the pioneer. She was the one who opened her parents' eyes to special needs kids and how well they can do in a loving, supportive family.

After Barbie, Nancy and Joe brought home Lisa, then Katie, then Michael, then Matthew—all from Korea. Then they started looking in other countries, adopting children from Hong Kong, India, then Bulgaria and back a few times to Korea. Each time they thought they were done, they would hear about a child who seemed to be another perfect fit for their family.

It's been 30 years since Barbie. Nancy and Joe adopted fifteen more after her. Maybe they're finished, maybe not. But they do agree that nineteen is a good number, considering a big family is what they wanted.

The Kayes kids range in age from 11 to 38. Nancy remembers them not in order of their ages, but by the order they joined the family. In that order, they are Becky, Greg, Andrew, Barbie, Lisa, Katie, Michael, Matthew, Mark, Tom, Kira, Lee Ann, Kristen, Joshua, Sarah, Brian, Alexander, Zachary and Christian.

Each one has a temper. Each one can be ornery. Each one can be so sweet and thoughtful, Nancy wonders where they get it. Two have spina bifida, three have cerebral palsy, one was born without arms, one has spinal tuberculosis, another has polio and on and on. But the thing is, they're all good at helping whoever needs help, whatever help they need. Which gives them the confidence to do what they might never have tried doing under different circumstances.

Mark is a good example. He's the Kayes who was born without arms. Imagine not having your arms. But that didn't stop Mark from being the manager of his high school football team. Or learning to type with his feet at the rate of 35 words per minute. Or getting a driver's license. Or any number of other things he does on a regular basis. If he thinks for a minute, he can figure out how to do most anything.

For Nancy and Joe, the journey has been an exciting one. They are never bored. They never have nothing to do. They're still climbing bleachers—these days, to watch Zach and Chris play basketball.

They're still going to PTA meetings, still showing up at "Meet the Teacher" night every autumn.

That's because they believe every child has as a right to a decent life in a loving, supportive home. They will tell you that adoption is a beautiful way to build a family.

At the same time, they will tell you that you have to be realistic and know that every family faces challenges and every child is different. They will tell you that you can't live out your hopes and dreams through your children. Kids have to develop their own hopes and dreams, and you just have to find ways to nurture their dreams.

Nancy wishes more people would adopt kids with special needs. They're great kids who happen to have a challenge of some sort, she says. It doesn't change their value in any way. She wishes, too, that more people would consider older kids, since they're so often left behind.

"I tell you this: I wouldn't trade our life for anyone's," Nancy says.

"Joe always says our life has been a roller coaster ride, but what a ride it is! We're happy to just keep riding."

The Wood Family

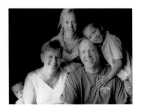

Introducing the Woods:
Sue, Steve, Lindsay, Tom, John

Tom Wood is a chatty, high-energy boy. He's also one of those kids who is wired to compete—over anything and with whomever happens to be around. Usually, it's his twin brother, John, because they're mostly around each other.

For now at least, at the age of five, here's how Tom sees the world: When he gets out of bed before John, that's good because he got up first. When he gets up after John, that's good because he slept longer.

Their parents, Sue and Steve, have observed that Tom is actually a smidge taller and a bit faster than John—although, for his age, he is of average height and speed. Sue finds him an intriguing boy to be bringing up, since she considers herself to be the least competitive person who ever lived.

Tom is happiest when he thinks he has the advantage. The fortunate part of all this is that John could not care less about who is taller or who is faster. Or who sleeps longer or who gets up first. John is just a happy, gentle, kind-hearted boy who wakes up every morning smiling. John is delighted to be here, wherever he is.

One thing they share is their love of ice cream—although Tom prefers chocolate, and John's favorite is vanilla. Another is their fourteen-year-old sister, Lindsay. The twins have become adept in their roles as pesky little brothers. Lindsay adores them, Sue says, but they

do drive their sister crazy. If you think about it, though, that's what little brothers are supposed to do.

The boys could hardly be more different. John loves guy stuff—trains, fire trucks and police cars. He would like to drive a big mail truck when he grows up. Tom is happiest when he's playing soccer or imagining he's a superhero. His career plan is to be a Red Power Ranger when he gets older, although his mother suspects that could change.

Tom is social, John less so. Tom is easily frustrated, but John has a tenacity and patience of character that surprises his parents.

The twins were born in Vietnam. Sue and Steve chose to adopt because they know too many children are born in this world without families and because they had a family with plenty of love to share. They can't even begin to explain how much joy John and Tom have brought into their home.

The Meyer Family

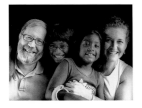

Introducing the Meyers:
Michelle, Michael, Magdalena, Matthias

Michelle Meyer sometimes gets comments from people who mean well, yet they still strike her as strange. They seem to think she and Michael are saints for adopting a boy and a girl from Calcutta—especially Magdalena, who has ongoing medical issues.

Michelle tries to explain that they adopted because they wanted a family. And because she couldn't imagine not being a mom. And because she and her husband wanted to share their love with children they could call their own. They love their kids not because they're cute or clever or kind or funny, but because that's what parents do.

"We love our children and take care of them because they are ours, not because they were orphans or because they have medical needs," Michelle says.

"We pick them up when they fall down. We help them discover who they are. We're a family, different from every other family and just like every other family."

Matthias is ten. He is fast at almost everything he does—running, talking, thinking, learning. Seven-year-old Magdalena is a singer with a sweet, pretty voice. She sings when she plays, she sings in the shower, she sings in the choir at church and she and her mother sing together before she goes to sleep. She even sings her vocabulary words while doing homework.

As things stand now, Matthias would like to be an NBA star. This is one of the advantages he has now that he's an American, because kids are encouraged to think big here. He has also given some thought to careers in the NFL, paleontology and as a professional potato-chip taster.

Magdalena draws her influences from those who mean the most to her. She has talked about being a teacher, a ballerina or a physical therapist—she has been in therapy since she was seventeen months old as a result of moderate cerebral palsy. Her enduring interest, though, is to be a mom. She talks about having a boyfriend and how they'll get married one fine day and have babies of their own.

Matthias works from his head. He likes his time alone and tends to be reserved in new situations. Magdalena trusts her instincts. She is what she seems to be, which is to say you never have any doubt about how she feels about this or that. She does sometimes get herself into trouble when she acts before thinking something through, but she is quite happy making new acquaintances.

One of her favorite people was her Grandpa Monnin, Michelle's father. Michelle says they were great cuddle buddies. With Magdalena, he was able to show his affectionate side, something that wasn't always easy for him. And with Grandpa, Magdalena had a devoted admirer.

When Grandma Monnin was dying of cancer, and afterward, Grandpa and Magdalena were often seen snuggling in his rocking chair. And when Grandpa died not quite a year later, Magdalena's aunts and uncles decided memorial donations in Grandpa's honor would go to a medical fund for Magdalena. The thank-you notes for those donations included a photograph of the two of them in that rocking chair, with the caption, "I love my grandpa, and my grandpa loves me."

The Davis Family

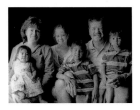

Introducing the Davises:
Aimee, Mark, Katie, Marco,
Gustavo, Ana Lucia

Different experiences stand out for different reasons. For Aimee Davis, one such moment occurred during the process of their family's third adoption, when she and her eleven-year-old daughter, Katie, were in Guatemala. Aimee got a call from the agency she and her husband, Mark, were using. Would she like to meet a baby who might possibly be her referral?

"Yes," she said. "Of course, sure, absolutely."

It was a risk. For Aimee, it was love at first sight. The baby was six days old, a girl. But Aimee didn't know if she would be the one. She was allowed to hold the baby and even feed her a bottle, then reluctantly placed her back in the car seat.

"I'll never forget the feeling of holding our daughter before she became our daughter," Aimee said.

This would be the child Aimee and Mark would name Ana Lucia, sharing the name with her birth mother. Four months later, on March 18, 2006, Aimee arrived home from Guatemala with Ana Lucia in her arms. Waiting at the airport were Mark, the home-grown kids, Zack and Katie, and their brothers, Marco and Gustavo, both born in Guatemala.

As they headed home from the airport, Aimee looked back and realized that all seven seats in their car were taken. Their family was

complete. It was a golden moment, with all four older kids getting to know their new baby sister. Suddenly, Marco had a question: Where will Ana Lucia sit at the dinner table? Without missing a beat, Gustavo offered his high chair.

In this way, Ana Lucia's transition into her new family happened. It took only a moment to complete.

With each of the five Davis children, the transition was immediate.

Aimee makes a point of telling her children, both biological and adopted, that each has his or her own place in her heart. Zack is the one who made her a mom. Katie is the one who gave her a daughter. Marco, the Davis' first adopted child, is the one who opened his family's hearts and minds to a whole new world. Gustavo is her miracle child—the Guatemalan government shut down foreign adoptions during his adoption process, and ten weeks passed before Aimee and Mark knew if they would be allowed to bring him home.

Said Aimee, "Ana Lucia is our 'follow your heart's desire' child. We wanted one more child to complete our family—and she was it."

Aimee has a nice way of talking about what it takes to be a family.

"Our children have helped us see that family isn't defined by sharing DNA but by sharing love. Three of our children don't look at all like Mark or me. We weren't present for their births. The first time we saw them wasn't in a hospital room—it was in a hotel lobby or a foster home in a third world country. The real magic is that those circumstances don't make them any less our children.

"At the end of the day when I tell all my children good night, they truly are all my children."

The Koenig Family

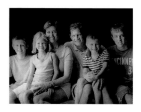

Introducing the Koenigs:
Cathy, Tom, Joe, Scott, Tim, Christina

Christina spent her first two years in a Russian orphanage, which is a good part of the reason it took as long as it did for her to take much of anything for granted.

The first few months after her adopted mother and father, Cathy and Tom Koenig, welcomed her to her new home in Ohio, she would all but lick her plate clean. When Cathy would give her a cup of something to drink, she'd gulp it down until it was empty. And if something was served to her in a bowl, she would wrap a protective arm around it, as if to keep anyone from taking it away.

She wouldn't let Cathy out of her sight. Everywhere Cathy went, Christina went, too. At home, she was Cathy's shadow, toddling after her from one end of the house to the other. The Koenigs' agency had told them to expect it. They were told that when a child is removed from the only home they've ever known, even if that home was an orphanage, it is a frightening experience, filled with apprehension.

For small children, especially, they're suddenly taken away from what they know and introduced to so much that's new to them—new sights, sounds, smells, touches—not to mention a language they can't understand. Cathy believes that because she was the one who carried Christina out of the orphanage, she became the child's connection between the old world and the new. So Christina wasn't about to let her go, not until she learned to trust.

Cathy was constantly telling her, "I'll be right back." The day she knew Christina had learned to trust was the day she and her younger brother, Tim, were seated at the kitchen table in their booster seats. Cathy had to leave the kitchen to answer the doorbell. Tim started crying, and Cathy heard Christina comforting him in her broken English with her authoritative Russian inflection, "No cry. Mommy right back."

Christina is seven years old. She has three brothers—Tim, who is six, Scott, twelve, and fourteen-year-old Joseph. Their sister, Jennifer, died eight years ago after a long illness. She was eight years old. Although Christina is only six months older than Tim, she is his little mother. Almost from the beginning, she took him under wing, helping him dress, serving his drink, getting him what he couldn't reach himself.

Christina is a helper. She's always the first in the house to offer to get the extra gallon of milk from the downstairs refrigerator, set the table for dinner, fold the laundry or whatever else needs doing. When the family sits down for a game of Trouble, if Christina has rolled a string of sixes and Cathy hasn't, she will offer a six to get her mom back in the game.

"I just love it that, because Christina is not our biological child, we have no expectations of her, which means she's free to be herself," Cathy said.

"It's not like she has my way of thinking or Tom's way of this or that. She's totally Christina, and she continually surprises us with who she is."

The Kurlas Family

Introducing the Kurlases:
Robin, Dennis, Tyler, Jade, MeiLian

Robin and Dennis Kurlas began their family with Dennis' two sons, Nick and Tyler, who are now in college. They decided to add to their family and went to China for a little sister for their sons. It was Jade's idea for them to go back again to get a sister for her. For two years, she begged for a sister and didn't stop until she'd convinced her parents that it was what they needed to do.

Jade is eleven and was born in the province of Guangxi. She was three when she took up the cello and performed her first recital at the age of four. She was nervous, her mother says, but only because of the anticipation. As soon as she played the first note, she was off and running, focused on the performance.

MeiLian is five. Robin and Dennis went to the province of Guandong to bring her home. For one so young, she is remarkably disciplined. She performs tasks completely and correctly. For example, if there are groceries to be brought in from the car, she makes as many trips as it takes to get the bags out of the trunk. She holds the door open for others, puts the groceries where they belong, disposes of the empty bags and makes sure the garage door is closed.

Jade has begun thinking about what she would like to do with her life. The options she is considering include cello teacher, singer, actress, fashion designer and chef. Her mother allows that she has an

artist's temperament in that she prefers to do things in her own time and on her own terms.

In any case, Jade is direct and to the point. That comes through in this letter she wrote:

Dear Santa,

I, Jade, want a laptop. Mei wants books. If you can write and type my book report, that would make my day. But I understand if you don't.

Love, Jade

MeiLian is dutiful and considerate. She sees to the little things. If there is a tray of homemade cookies, MeiLian always offers the last one to someone else. She supposes she would like to find some sort of job looking after animals when she is older, especially if someone needed help taking care of rabbits.

Both girls are determined and caring. They are different in that Jade is more dominating, likes to control situations and has a variety of moods, perhaps owing to her artistic bent. MeiLian is more easygoing and able to go with the flow.

Like every other parent who has ever adopted, Robin and Dennis say it's difficult to explain the joy their children have brought them.

Then they go ahead and explain it precisely.

"Every day, we think of how fortunate we are and how much Jade and MeiLian have enriched our lives," Robin said.

"They're both amazing girls, and we learn from them constantly. Children have a way of putting things in perspective for adults who may have forgotten."

109

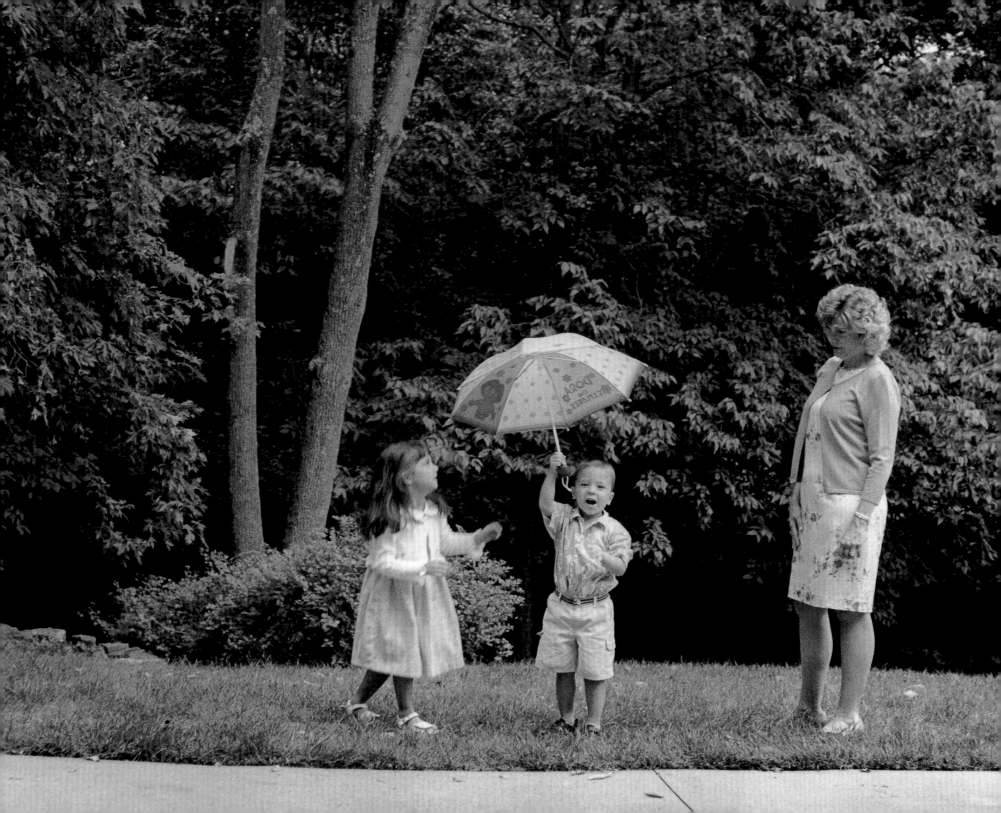

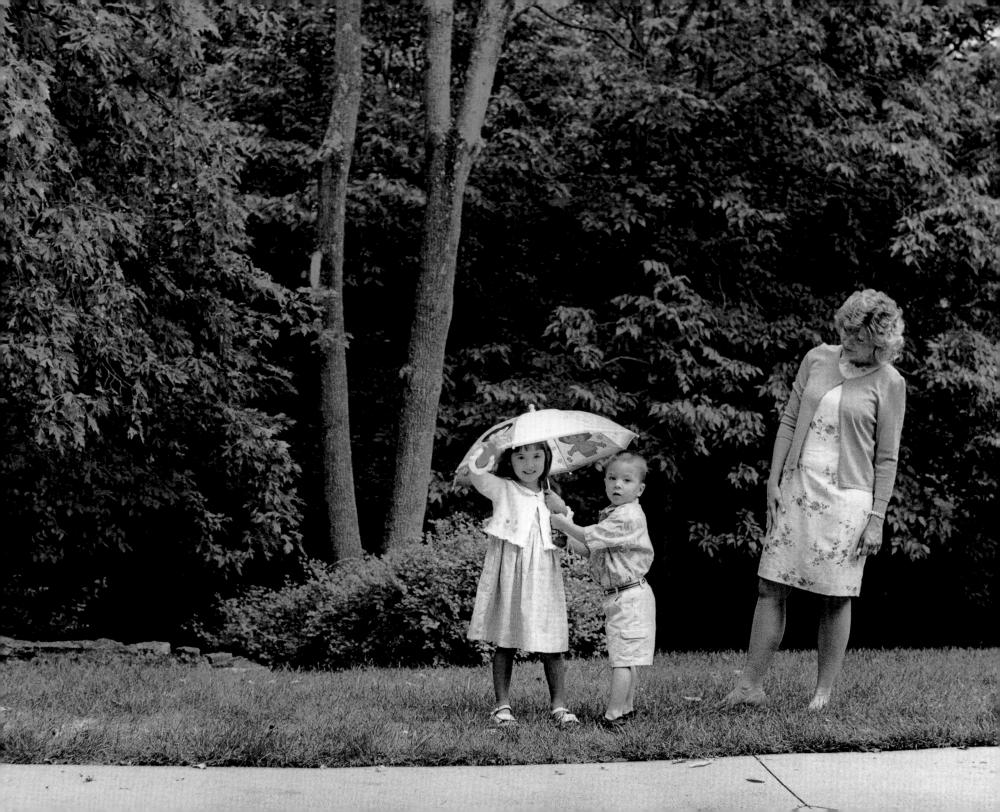

Additional Information

How "Now We Are One" Came to Be

I have always been moved by the powerful way photographs tell stories, especially stories of childhood and family.

When my husband, Karl, and I adopted our second son, I wanted to share with others the joy of adoption. "Joy" is the word I've often heard friends use to describe the experience of growing their family this way, and I thought that a book of photographs would be the best and most compelling way to express that emotion. I had long admired Michael Wilson's photographs for their simplicity, sensitivity, and lack of pretense. I knew that he lived locally, and that he had a reputation for being an exceptionally nice guy. I gave him a call to see if he might be interested in the project.

My first conversation with Michael was late in the summer of 2005, not long after Karl and I returned from Guatemala with our second son, Henry. I spoke to him about my motivation for doing a book. I wanted to portray international adoption as a valid, loving way to build a family, and I thought that a book of photographs of healthy, happy families (with kids who happen to have been born in different countries) might help "normalize" the whole topic. In recent years, international adoption by celebrities—while admirable in itself—has become tabloid fodder and created a circus atmosphere that misrepresents the reality for thousands of ordinary families.

I was certain of only a few details: the book would have to show its subjects in a positive light; the love between all members of these families would have to be clear; and all proceeds from sales would necessarily benefit adoption related causes. Although Michael had no personal experience with international adoption, he readily agreed to the project. He made arrangements to visit our home two weeks later to photograph our family. After that, he made appointments with other families and quickly began to build a portfolio of lovely, thoughtful work. With each visit, he was able to find new and different ways to capture the one-of-a-kind personality of each child, and the ways in which each child connected with his or her family.

As the project began taking shape, Michael and I realized it was lacking something. Words? Stories? We weren't sure exactly, but we sensed that we needed a writer who could understand the human side of each family's tale and who could write simple, respectful textual portraits to accompany the images.

Michael suggested David Wecker, a friend and veteran newspaper columnist. David was happy to accept the assignment, telling Michael that he'd been looking to do some "heart work." He seems to have found it. I hoped the writing would emphasize the personalities and talents of each child, along with the happiness they bring to their families. David let each family's story speak for itself.

I hope that *Now We Are One* will give greater understanding of the beauty of adoption for children, all over the world, who are waiting for families of their own. And that it will present a clear picture of the joy adoption can be for everyone touched by this extraordinary experience.

Marguerite Gieseke, January 2007

Acknowledgments

This book would not be possible without the help of many wonderful people with a kind heart for children and their welfare. First, I would like to thank all of the families who agreed to be photographed and interviewed. You are all remarkable and I appreciate your participation. I am beyond grateful to Michael Wilson and David Wecker, whose talent and commitment are uplifting and inspiring. A special thank you to Tom Schiff for his support and Jacob Drabik for his creative eye for design and dedication to the project. Many thanks to Melissa Faye Greene for her beautiful piece and the energy she devoted to it during such a busy time in her life. A heartfelt thanks to Stephen McCauley for his encouragement, advice and willingness to get involved in the project. I owe a debt of gratitude to Nancy Kayes for her friendship and honest insight. Also, a sincere thank-you to my dear friends Erika Barnes, Jane Larkin, and Cathy Koenig for their laughter and kind words. I would also like to thank my parents Lynn and Jack Schiff for far too much to mention here; my brothers, John and Charlie; and my sister-in-law, Christine. Many, many thanks to my kids, Anna, Mary, Lily, Jamie and Henry, for being both funny and kind. Most of all, thank you to my husband and best friend, Karl Gieseke, for his support, laughter and love.

M.G.

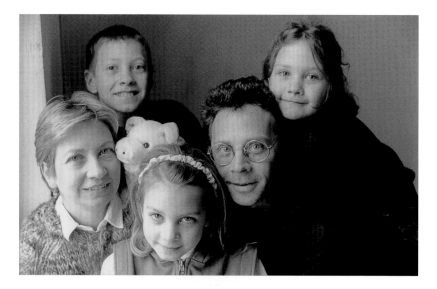

Michael with his wife, Marilyn, and their children, Henry, Polly and Sunny

About the Artist

Michael Wilson had been saving for a French horn when he realized he didn't have the faculties to play the instrument. So he bought a camera. This was in 1976, when he was about to graduate from Norwood High School in Cincinnati. His black-and-white photographs seem to find the extraordinary in everyday situations. He hopes his photographs are honest, but he worries about ever really getting there. His subjects would disagree. He also has a gift for making you forget you're having your picture taken. Michael and his wife, Marilyn, have three children whose names are Henry, Polly and Sunny.

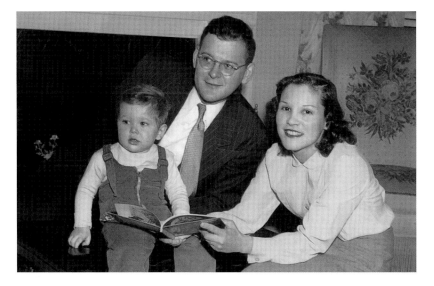

David with his parents, Willard and Dorothy

About the Writer

David Wecker had a crush on his fourth-grade teacher, Miss Lafferty. One day, she returned an assignment with a note she'd jotted: "You write beautifully. Ever thought of being a writer?" So he did. He wrote a column about people for twenty-some years for The Cincinnati Post and Kentucky Post. Now he writes business tales for his company, Fingerprint Brand Storytelling. When he can write about real people and real emotions, he's happy to. He and his wife, Karen, live in a 200-year-old log house. David has a son, Sam, and a daughter, Betsy, both students at Centre College.

International Adoption Resources

The International Adoption Center

More than 20,000 children immigrate to the United States each year to begin a new life with their adoptive parents. Most are quite young- less than a year old- and nine out of 10 have not yet reached their fourth birthday. They come primarily from Russia, China, Europe and Central and South America. They bring with them unique and complex health issues- medical, developmental and psychological. The International Adoption Center (IAC) at Cincinnati Children's Hospital Medical Center is a non-profit organization committed to the health and wellness needs of these children and their families.

The IAC was founded in 1999 by Dr. Mary Allen Staat, a highly respected, nationally recognized doctor with certifications in Pediatrics, Preventive Medicine and Pediatric Infectious Diseases. In addition to her stellar credentials, Dr Staat is the mother of three happy, healthy children, adopted from Central and South American countries. Under the stewardship of Dr. Staat, the IAC provides essential medical and psychological services, emotional support, community programs and research that help internationally adopted children and their families enjoy healthy and well-adjusted lives.

Sonya and Tom Zumbiel were grateful for the expertise of Dr. Staat and the support of the IAC while they were in the process of adopting their son from Guatemala. "Dr. Staat was wonderful, Sonya remembers… she was able to review what little medical information we had and provide us with sound advice on our son's health and development while he was in Guatemala and then after he was home. Like all parents, we had a lot of questions and concerns and Dr. Staat was able to address them professionally as a doctor and also as a mom, who understands the emotional side of adoption. She was an excellent resource and gave us much needed peace of mind during an emotional time."

Dr. Staat is proud of the IAC an its role in helping to build families…" Adopting a child from another country is one of the most beautiful, life enriching experiences a family can have. I would hate to see anyone bypass this opportunity because the right medical resources weren't within reach." For more information please call (513) 636-2877 or *www.cincinnatichildrens.org/IAC*

Adoption Today

Adoption Today is a magazine that serves as a comprehensive guide to the issues and answers surrounding international and domestic adoption. Written by adoptive parents, adoptees and professionals, it offers helpful insight into the many different aspects of adoption. They may be contacted at *www.adoptinfo.net* or call 1-888-924-6736 to subscribe.

Adoptive Families

Adoptive Families magazine offers a wealth of information for families before, during, and after adoption. They may be contacted at *www.adoptivefamilies.com* or call (800) 372-3300 to subscribe.

Tapestry Books

Tapestry Books offers a wonderful catalog of adoption related books as well as a website. The knowledgeable staff at Tapestry is committed to providing access to resources in both domestic and international adoption and offers a wide range of book selections. They also offer books on adoption for children of all ages. Visit the website at *www.tapestrybooks.com* or call (877) 266-5406 for more information.

Exceptional Development Organizations

It has been the focus of this book to present a happy aspect of international adoption—the families that are created and strengthened by it. But there is a long and sad list of world events that set these adoptions in motion. Quite often, when families bring home a child, they find that these faraway problems become much more immediate for them, and they begin to look for ways to become involved.

Although they are not involved in adoptions, the development organizations listed here operate in two of the most common countries for international adoption, Guatemala and China. The inspired and committed staffs of these organizations have developed far-sighted programs that deliver fundamental, lasting benefit to the populations they serve.

Cooperative for Education

Education is the most powerful tool to help people step out of poverty. Unfortunately, the state of education in Guatemala is abysmal. In many rural areas, nearly three out of four adults cannot read or write and only 9% of children continue their education past the sixth grade. In addition, rural schools in Guatemala lack the most basic educational materials; 90% of secondary schools do not even have textbooks.

Cooperative for Education, a Guatemala City- and Cincinnati-based non-profit organization, offers sustainable educational opportunities to Guatemalan children. By setting up textbook cooperatives, computer centers and libraries in impoverished schools, CoEd is helping Guatemalan schoolchildren break the cycle of poverty through education. Cooperative for Education is effectively providing the tools necessary to help these children break out of the poverty that has plagued their families for generations.

CoEd also offers the chance to see first-hand that these programs are making a difference. Twice a year, volunteers travel to Guatemala with CoEd to deliver textbooks and library materials and to inaugurate computer centers. David and Jennifer Withrow are two such volunteers who have traveled with the Co-ed on their book tours and have returned forever changed by the experience. "I was looking for a way to give back to the country where my children were born. CoEd provided me with that opportunity and so much more. This trip gave me a glimpse of what my children's lives would have been like had they not come to us—the beauty of the culture, but also the struggles they would have endured. I would recommend it not only to adoptive parents, but to anyone who believes in the power of education to unlock doors. My last CoEd trip was particularly gripping. As I stood in the school yard of a remote highlands village and listened to those beautiful children sing their national anthem, a bitter-sweetness came over me. I thought of my own children—of the culturally rich traditions they would be missing. Yet there are so many opportunities they will enjoy in their new country. And, of course, I thought of these indigenous children wracked by poverty and hardship mostly because they are deprived of educational advantages. I love my children and thank God daily that they came to us. Still, as I stood in that dusty village square, I could not help but hope that one day no child would have to be adopted away from Guatemala because of poverty."

If you would like more information about Cooperative for Education or how to get involved, please visit *www.coeduc.org* or call (513) 731-2595.

Half the Sky Foundation

"We are all one family. And families take care of each other." Jenny Bowen, executive director, Half the Sky Foundation.

When Jenny and Richard Bowen adopted their daughter, Maya, a toddler from a welfare institution in southern China, "We fell in love. Within an instant we felt that this child was destined to be ours. We felt the connection to her as surely as if we had given birth to her," says Jenny.

Like many adoptive parents, the Bowens also felt a deep connection to the tens of thousands of children still living in Chinese social welfare institutions: "Those children are the sisters and brothers of our daughters from China. We are all one family. And families take care of each other," says Jenny.

Vowing to help take care of the children left behind, a small group of adoptive parents, including the Bowens, started Half the Sky Foundation in 1998. With the generous support of individuals, corporations and foundations, Half the Sky has grown into a global organization that offers four programs for institutionalized children in China.

Half the Sky's programs provide nurture and stimulation for babies, innovative preschools that encourage an early love of learning, personalized learning opportunities for older children and loving and permanent foster homes for children whose special needs will keep them from being adopted.

The hugs, the smiles, the encouragement and the love offered by Half the Sky's trained staff can fend off the often tragic legacy of institutionalized care. Withdrawn, angry children can become the happy, loving, curious explorers they were meant to be.

Half the Sky has provided one-on-one, nurturing care to thousands of children in Chinese institutions, but there are still so many more children who need help. If you want to make a difference in the lives of children still waiting in Chinese institutions you can learn more about Half the Sky at *www.halfthesky.org*.

Index of Families